DSLR Photography - Antelope Canyon

How to Photograph Landscapes With Your DSLR – Vol 1

by Phil Billitz & Jerry Newman

4 Quarters Technology, LLC

Amherst, MA

4 Quarters Technology, LLC
141 N. Pleasant Street
Amherst, Massachusetts
01004

First Edition

Copyright 2014, 4 Quarters Technology, LLC
All Rights Reserved

For Hana

Table of Contents

Dedication .. 1
The Photograph That Took 20 Years To Capture 3
Where Is Antelope Canyon? ... 5
How Do You Get There? .. 7
Antelope Canyon Guided Tours ... 9
 Photo Tours vs Regular Tours ... 9
The Challenge Of Photographing Antelope Canyon 11
Antelope Canyon Photographer's Pass 13
DSLR Photography Tips & Settings 15
 Tips for shooting in the canyon. .. 16
 Recommended DSLR Settings .. 18
 Equipment Checklist ... 19
Be In Harmony With Something Greater Than Yourself 21
Upper Antelope Canyon by Phil Billitz 23
Lower Antelope Canyon by Jerry Newman 37
The End .. 51

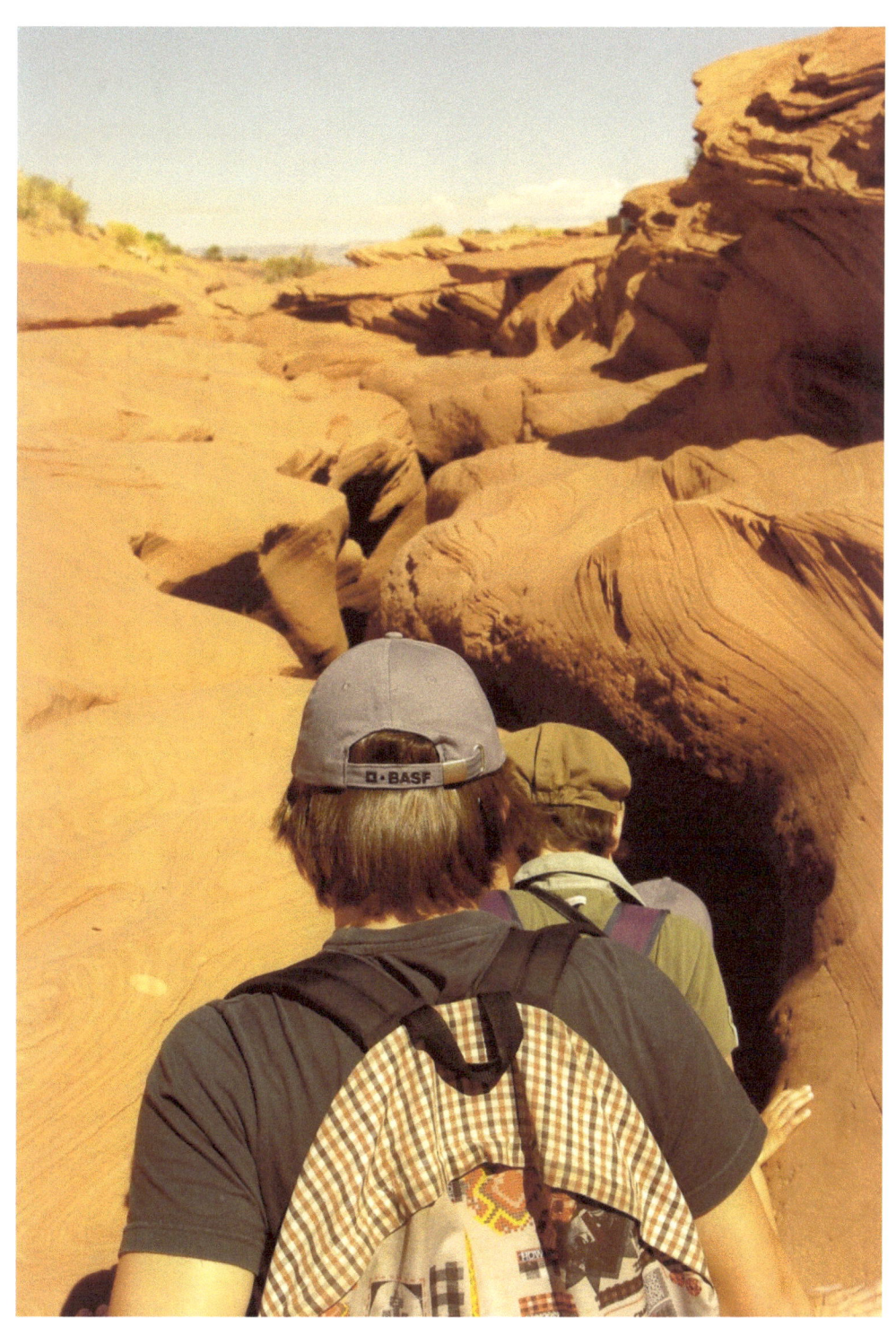

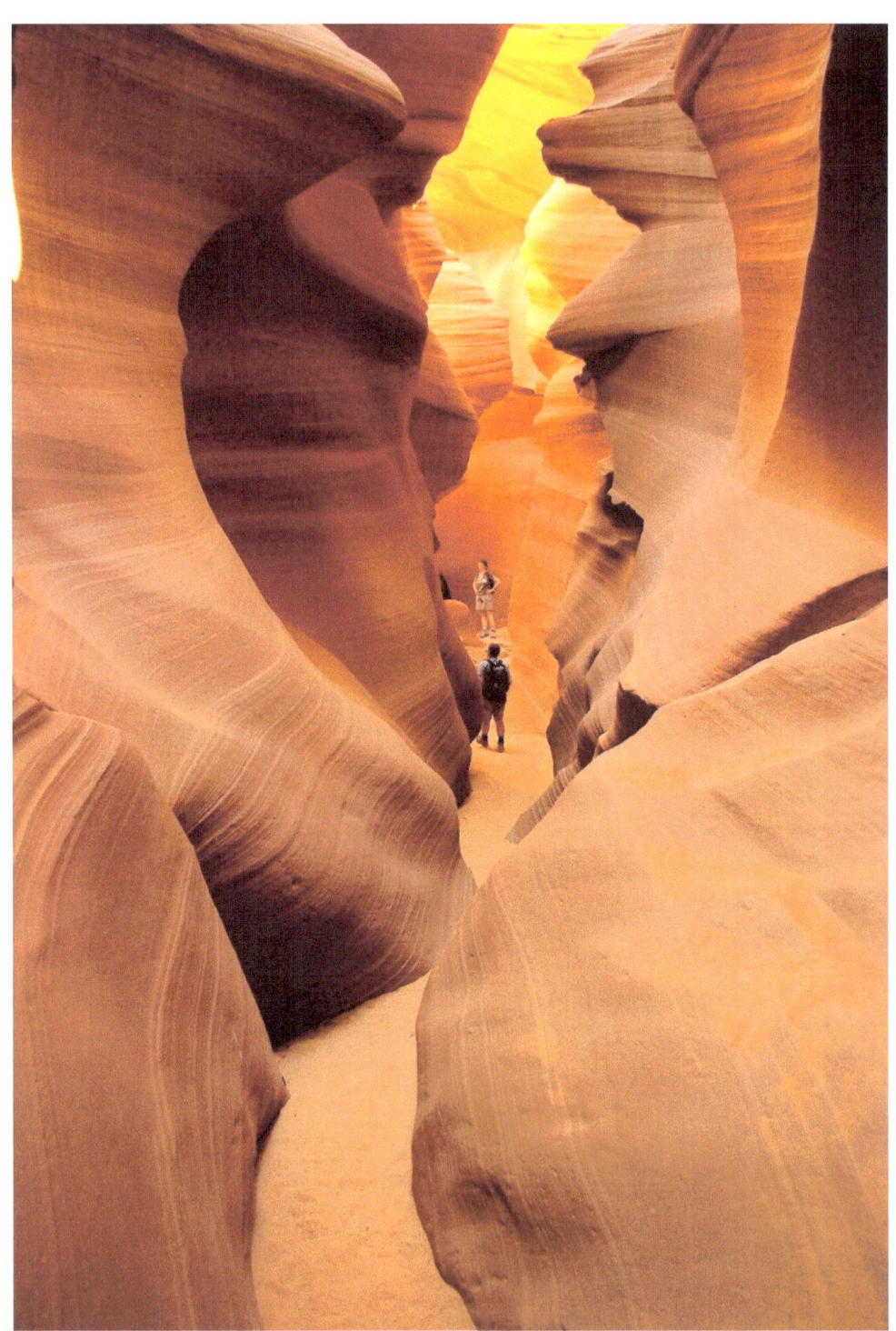

Dedication

We would like to dedicate this book to everyone who has been captivated by the landscapes of the Southwest and especially those who work to capture the images to share with others.

Our heartfelt thanks to the Navajo Nation for the opportunity to access and photograph these wonderful locations. The photos in this book are published with the permission of the Navajo Nation Film Office - Permit #3638.

Phil Billitz
Jerry Newman
2014

The Photograph That Took 20 Years To Capture

When I was just a kid, living deep in the piney woods of Alabama, my Uncle Claude and Aunt Lacy lived in Tucson, Arizona. For several years, they sent the family a gift subscription to Arizona Highways magazine.

Can you imagine the impact the beautiful photos in that magazine had on my impressionable mind? They might as well have been taken on another planet.

As an adult, I moved to Tucson and lived in southern Arizona for more than twenty years. I was an enthusiastic photographer and traveled extensively all over the state, taking thousands of pictures of that glorious, almost surreal landscape.

Once in a great while I would run across a stunning photo of swirling waves of stone, sculpted by water flowing through canyons cut into solid rock over countless millennia.

These "slot canyons" had names like Paria Canyon and Antelope Canyon. But exact locations and directions were difficult to come by.

I finally managed to get to some of the slot canyons feeding Paria Canyon, with names like Wire Pass and Buckskin Gulch. The hiking was fantastic, and my photographs sucked. The extreme range of exposure values was totally beyond my ability to capture, even after repeated attempts.

Finally, in 2010, with a couple of friends and my Pentax DSLR (Digital Single Lens Reflex camera), I signed up for a photo tour

of Upper Antelope Canyon, led by a smart, funny, friendly, and extremely knowledgeable Navajo guide.

It was more than a little humbling for my friends and me (who altogether had decades of photo experience) to get schooled by this diminutive Navajo lady.

But on that trip, with her help, I finally got the images that I had tried for so long to capture. Then, the following year, we did a similar tour through Lower Antelope Canyon.

We have included our best images from both trips so you can see the results of the techniques discussed in this book.

As it turns out, my images of the Upper Canyon were excellent, but not so great in the Lower Canyon (white balance setting was off). Jerry's results in the Lower Canyon were the best. He nailed the ISO and white balance settings there, after poor results in the Upper Canyon.

Where Is Antelope Canyon?

Antelope Canyon is located on the Navajo Nation in northern Arizona, USA. The nearest town with food and lodging is Page, Arizona. Page is located near the Utah border and is a major access area to Lake Powell, Monument Valley, and the Grand Canyon.

We recommend using Page as your base of operations.

As of this writing, Highway 89 is closed south of Page. So, if you are traveling north from Phoenix, you will have to make a long detour. You can get the most up-to-date info on road conditions and detours at http://www.azdot.gov/us89/.

How Do You Get There?

Many of the tour companies in Page begin their tours at a location in Page, then drive you to the canyon in their vehicles.

If you want to drive yourself to the entrance to either Upper or Lower Antelope Canyon, here are the directions from Page, Arizona (taken from Google Maps):

From Page, AZ

1. Head **northeast** on **S Navajo Dr** toward **S Lake Powell Blvd** 66 ft
2. Take the 1st right onto **S Lake Powell Blvd** 0.5 mi
3. Turn left onto **Coppermine Rd** 1.4 mi
4. Turn left onto **AZ-98 E** 2.2 mi
5. Turn left toward **Indn Route 222** 0.5 mi
6. Sharp left onto **Indn Route 222** 0.3 mi
7. Sharp right to stay on **Indn Route 222** 190 ft
8. Slight right to stay on **Indn Route 222** 226 ft
9. Slight right to stay on **Indn Route 222**
Entrance and parking will be on the left 0.2 mi

Lower Antelope Canyon
Indn Route 222
LeChee, AZ 86046

The turnoff to the Upper Antelope Canyon parking area is about 1 mile past the **Indn Route 222** turnoff on **AZ-98E**.

The entrance and parking area are on the right.

Antelope Canyon Guided Tours

You do not have a choice in the matter; if you want to photograph Antelope Canyon, you will have to hire a guide or take a guided tour.

There is a 2 hour limit inside Upper Antelope Canyon as well as Lower Antelope Canyon.

You can book a tour ahead of time with one of the many commercial tour companies based in Page, or just show up at the entrance to either canyon. Park in the parking area and go over to the booth and sign up for an ad hoc tour.

These tours are organized on a first-come, first-served basis and leave at regular intervals.

The downside of this kind of tour is that you will be walking with a dozen or so people. They may or may not be taking the time to get great photos, and keeping them out of your photos will be difficult.

Photo Tours vs Regular Tours

If you want to capture images like the ones in this book, take a photo tour. It will cost you a little more, but there are a number of benefits to paying the extra money:

- you will be in a smaller group (inquire when booking)
- you will receive good advice on camera settings for best results

- you will get tips on specific formations that are especially photogenic
- you will have more time to spend setting up and shooting each location
- the guides are patient as well as informative; they know you are there to take photographs and are eager to assist
- many guides will set up images for you with props; for example, see the photo of sand flowing in the Upper Canyon images later in this book

The Challenge Of Photographing Antelope Canyon

You will face a number of challenges besides just finding the place.

Geography - Both Upper and Lower Antelope Canyon are at about 4,000 foot elevation, and the canyon walls rise 120 feet above the stream bed.

Hiking is required - Upper Antelope Canyon is fairly level terrain. However, Lower Antelope Canyon has a number of steep iron staircases, and at the end of the canyon, you will have to climb stairs the equivalent of a three-story building on your return to the parking area.

Heat - It gets very hot in the summer—you are, after all, in the middle of the desert.

Crowds - There are multiple tours in the canyon at any given time; photos and videos that picture a quiet, empty, lonely landscape are not literally true. In the busy tourist season, you will have to frame your images carefully if you want to eliminate other people from your image.

Available lighting - It can be very difficult for photographers to get excellent results because of the available light ranges from bright sunlight to almost cave-like darkness.

Flash floods – In 1997, twelve hikers in the Lower Canyon were swept away and killed by a flash flood. That is one reason why having a guide is mandatory, and also why doing what the guide tells you may save your life.

Antelope Canyon Photographer's Pass

One way to photograph the canyon is to get a photographer's pass at the entrance to Lower Antelope Canyon, good for 2 hours, and you will be able to roam freely in the canyon without a guide.

The criterion for a photographer's pass seems to be having a mid-level to professional grade tripod with a DSLR or better camera. If you show up with a point-and-shoot or camera phone or a monopod instead of a tripod, you won't qualify.

I noted that everyone I saw with a pass had some pretty expensive equipment and was obviously serious about their photography.

All others are required to tour the canyon on the guided tours out of Page or the ad hoc tours organized by the guides at the entrance booth in the parking lot. There is a charge for these tours, and typically, they begin on the half hour.

DSLR Photography Tips & Settings

Using a DSLR camera in Antelope Canyon has many advantages. DSLRs provide the ability to preview the shot as you make adjustments, so you know what the image will look like before you snap the shutter.

Depending on the season and crowds, the Navajo guide will try to keep your tour group moving along. So, realistically, when you are on a tour through the canyon, you really won't have time to do a lot of adjusting and previews. Even with a photographer's pass, your time will be limited to 2 hours.

Taking DSLR photographs in there is like taking a photo:
- in a cave
- in bright sunlight
- in a room
- in wide open spaces

—all at the same time!!

Once you are hiking through the canyon, it is easy to miss a shot or series of shots because you forgot to change a setting.

And, there are so many incredibly beautiful places to photograph that you will want to concentrate on framing the images and not worry about your settings.

Tips For Shooting In The Canyon.

Best time of day – No matter what time of day you tour the canyon, there will be many opportunities for great shots. At midday, sunlight can reach the bottom of the canyon, which means that you will be faced with an extreme range of exposure values—from bright sunlight to dark shadow. Shooting in the morning or afternoon or on a cloudy day will help you avoid these extreme contrasts.

Depth of field – Unless you are deliberately trying to isolate an item in the frame, use the combination of slowest shutter speed and highest f-stop you can get away with. This will give you maximum depth of field, and more items in the frame will be in focus.

Exposure – Use the "brightness" control to increase or decrease the brightness of the primary object in the frame. If your DSLR has the ability to bracket the exposure, that is a good way to ensure getting a good exposure. Generally, try to get details in the lightest part of the frame and let the dark areas go to black. Shoot to get the color right for the part of the image that is in focus and the center of attention.

Composition – Put something in the foreground of your picture to give the illusion of depth. There is plenty of opportunity for repetition in the forms and line; contrasting dark and light areas; and contrasting colors. Add a vanishing point, and have lines leave the frame at the corners.

Take a lot of pictures – For most people, a trip through Antelope Canyon is a once-in-a-lifetime experience. Take a lot of pictures and save the best ones. Pixels are cheap. It is easier to select the best shot from several different exposures of an image than it is to look at a poorly exposed image on a camera display and then take the time to figure out what went wrong.

Tripod – You should definitely use a tripod or monopod. If you do not have one, you can brace the camera against a rock or wall, but it is worth the extra effort to carry along a tripod.

Lens – Avoid changing lenses in the canyon. It can be a dusty environment and this NOT a good place to open up your camera. Use a Zoom lens for maximum flexibility, I recommend a 35-105mm.

Gratuities – It is OK, and recommended, to tip your guide at the end of the tour — especially if they really helped you get great results in your photos.

Recommended DSLR Settings

Remember, it is very important that you figure out how to adjust the settings on your camera BEFORE you go into the canyon.

White balance - This is one setting that will really improve your results. Preview the frame while checking the different color shifts resulting from the different white balance settings. The "Cloudy" or "Shade" settings will probably work out the best. In most cases, leaving white balance set to "Auto" will give poor results.

ISO or sensitivity – An ISO of 400 is recommended. Lower ISO settings will cause you to have blurry images because of camera shake—higher ISO settings will tend to make your images appear grainy.

Shutter speed – Set the shutter speed to auto, or at a minimum speed of 1/200 sec with no tripod, or 1/30 sec if you are using a tripod.

Anti-shake – Turn on this feature if you have it.

Exposure bracketing – Turn on this feature if you have it. Otherwise manually over-expose and under-expose each shot.

Flash – Don't use a flash unless you want to illuminate objects in the foreground, especially with white balance set to "Cloudy."

Light meter – Use center-weighted or spot metering if your camera has these features. This will set the exposure for the shot based on the primary object in the frame.

Equipment Checklist

- DSLR (Digital Single Lens Reflex) Camera with a minimum of **10 megapixels**
- Zoom lens - approximately **35-105mm** gives you a lot of flexibility
- Tripod or monopod
- Extra batteries or power packs for the camera
- Extra memory cards for the camera
- Bottle of water
- Hat & sunscreen
- Sturdy hiking shoes

Be In Harmony With Something Greater Than Yourself

When you tour Antelope Canyon, you are a guest on the **Navajo Nation**. As such, you should be aware that the local laws, customs, and practices may be different from what you are used to.

Local laws are enforced by the **Navajo Nation Police**.

All areas on the Navajo Nation are closed to non-Navajos unless you have a valid camping, hiking or backcountry permit issued by the Navajo Parks and Recreation Department or other duly delegated tribal authority. Failure to have a permit is considered Trespassing on a Federal Indian Reservation.

The traditional customs of the Navajos embody a deep reverence for Nature, the Land, and the Landscape. Conduct yourself accordingly. The navajonationparks.org website has this description:

"To older Navajos, entering a place like Antelope Canyon was like entering a cathedral. They would probably pause before going in, to be in the right frame of mind and prepare for protection and respect.

This would also allow them to leave with an uplifted feeling of what Mother Nature has to offer, and to be in harmony with something greater than themselves. It was, and is, a spiritual experience."

It was a spiritual experience for me, and when you approach it with the right attitude, it can be a spiritual experience for you as well.

Upper Antelope Canyon

by Phil Billitz

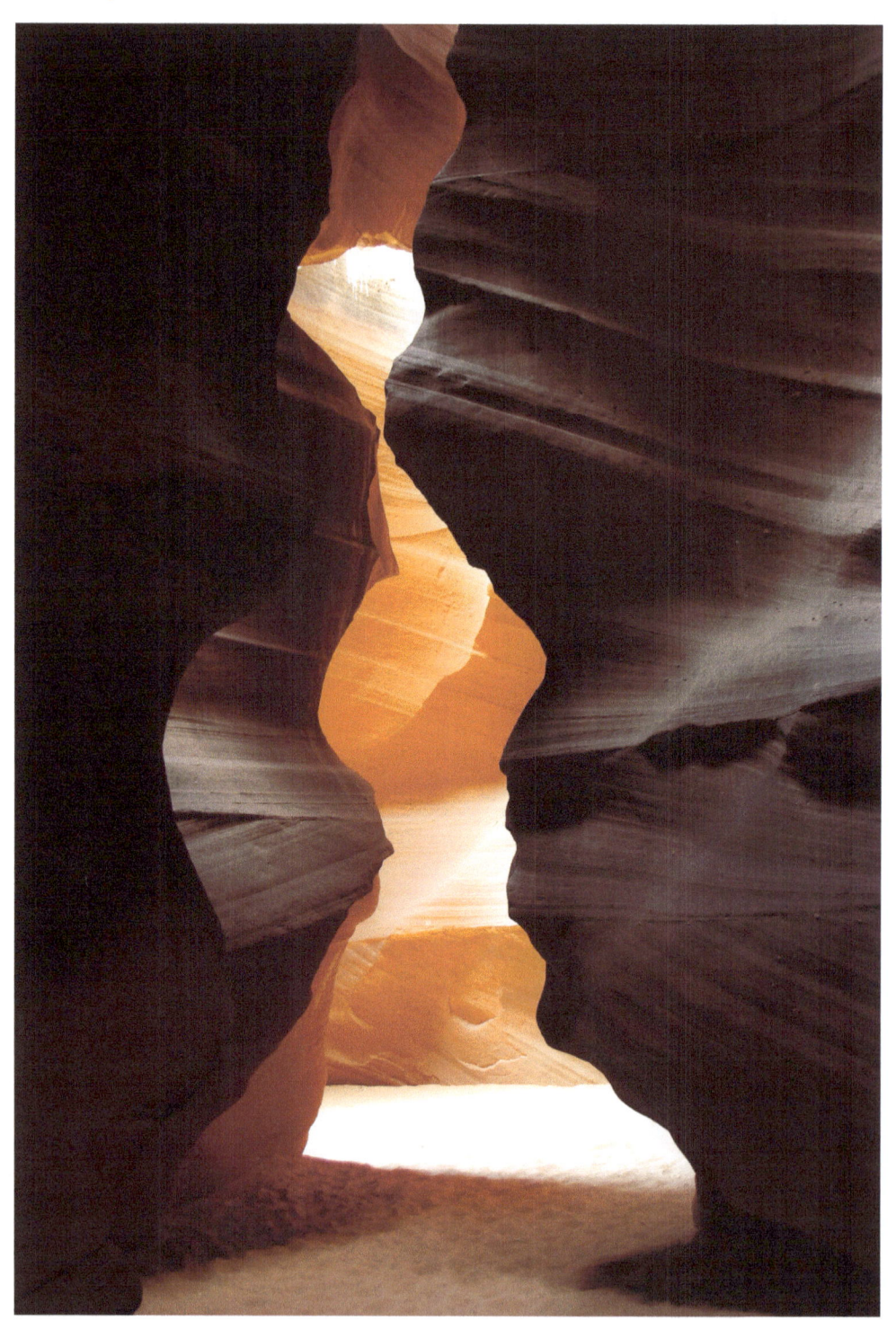

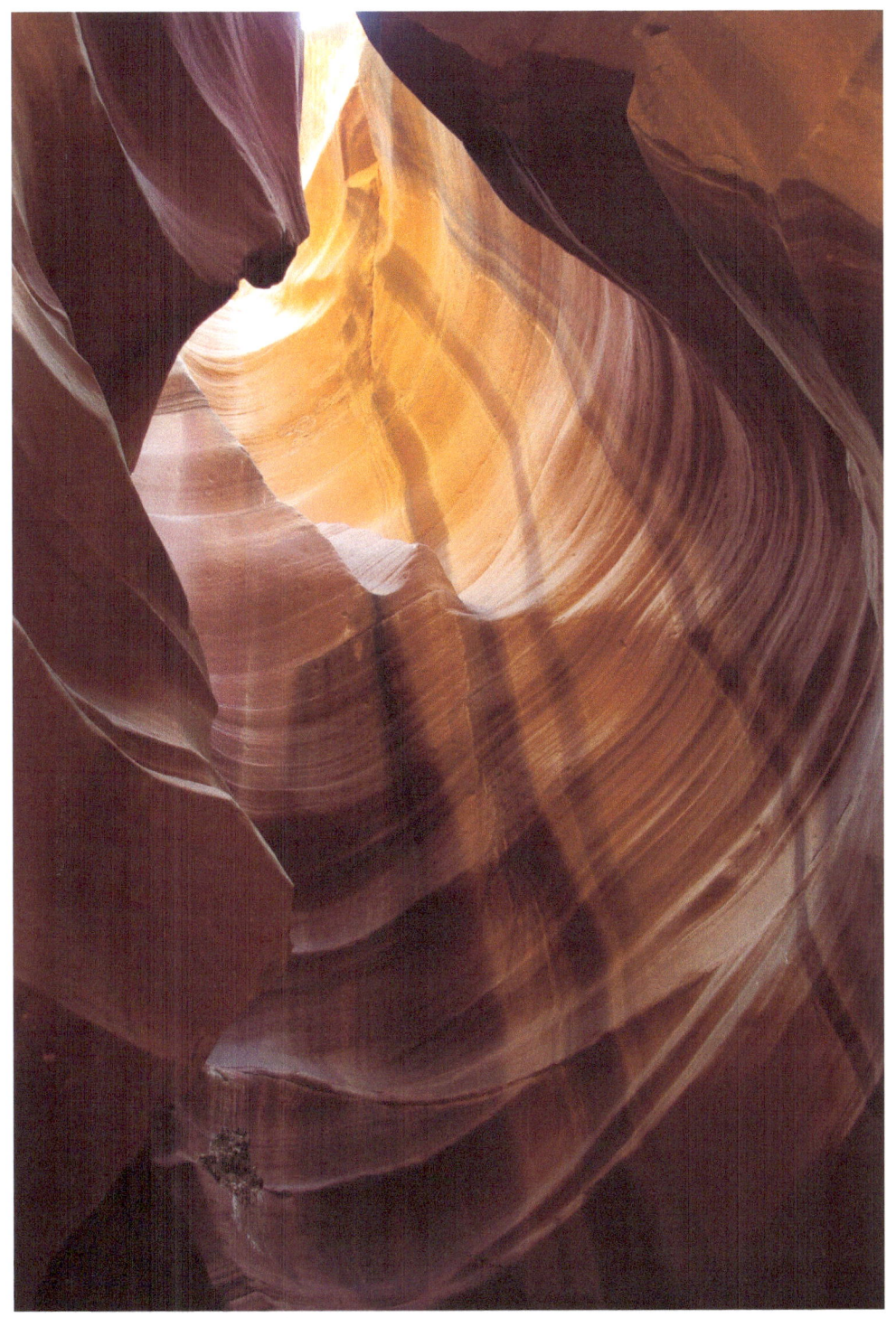

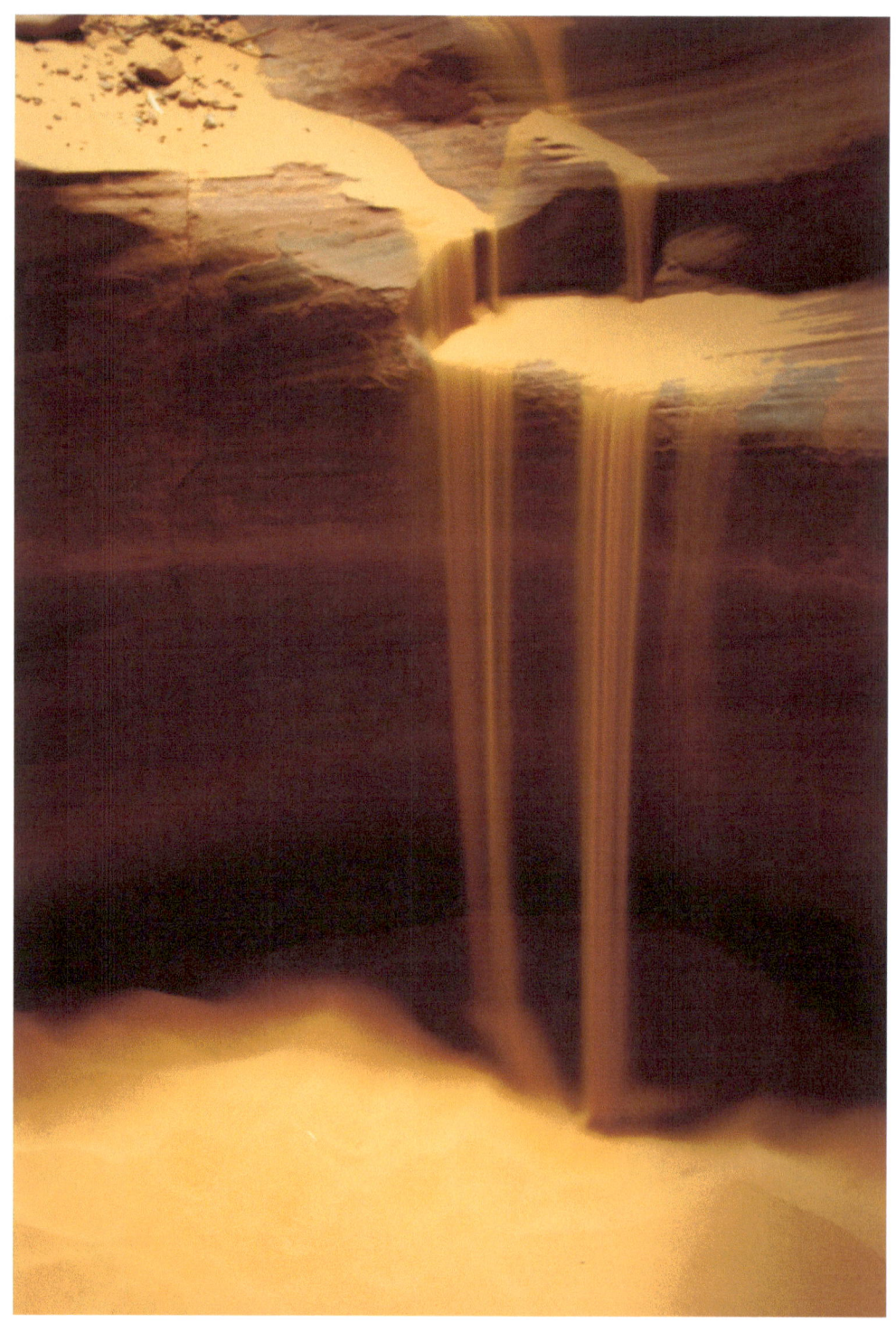

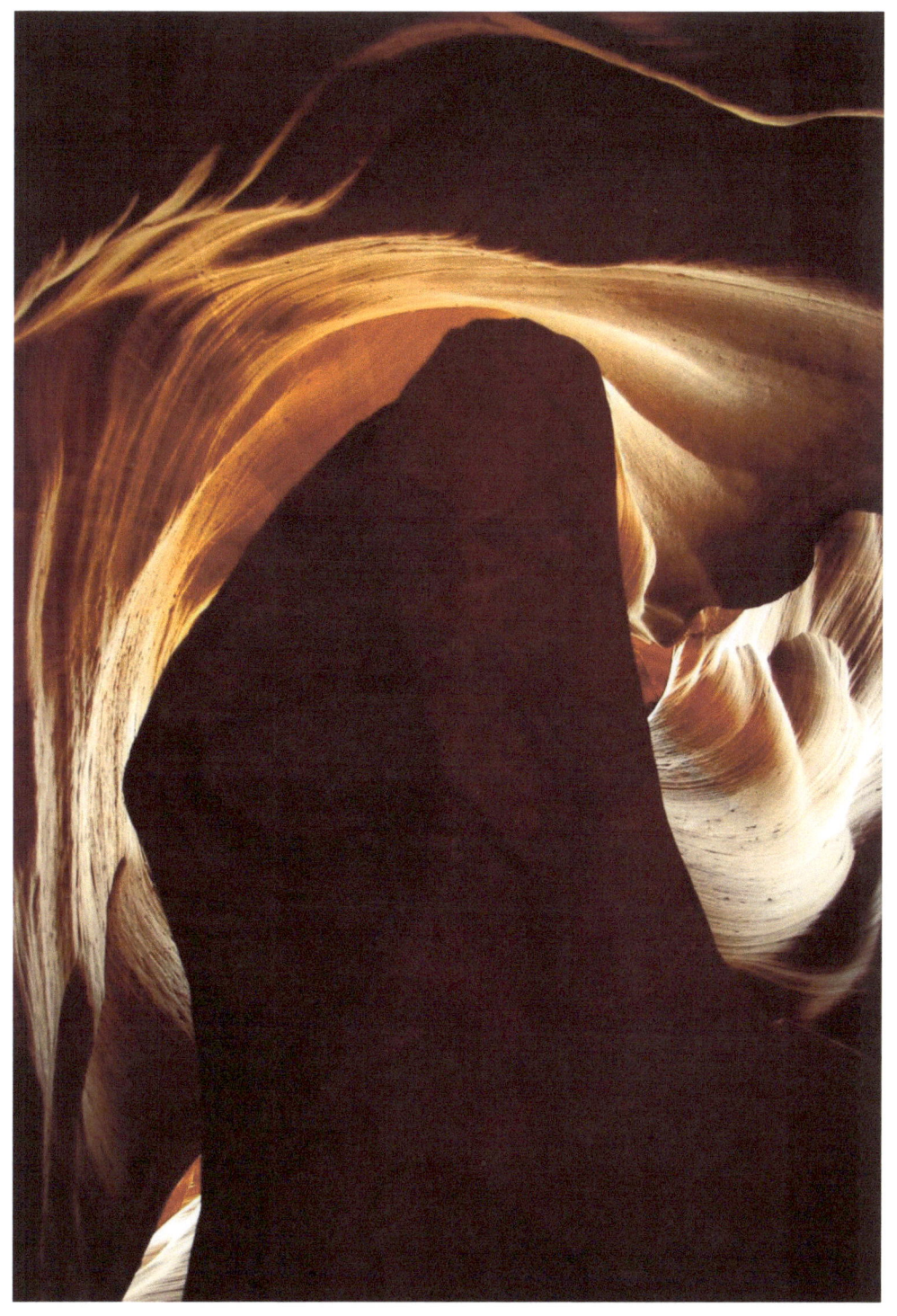

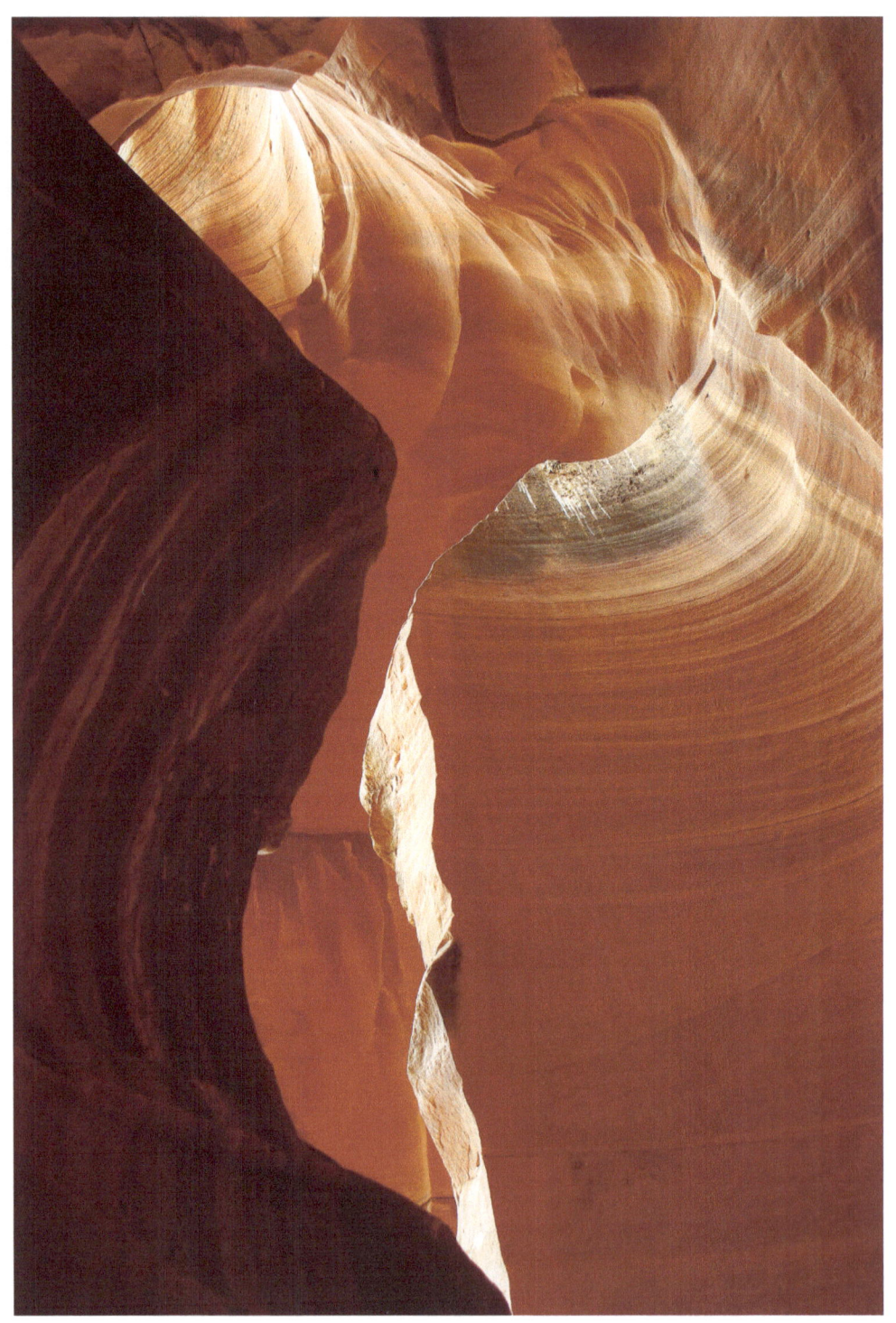

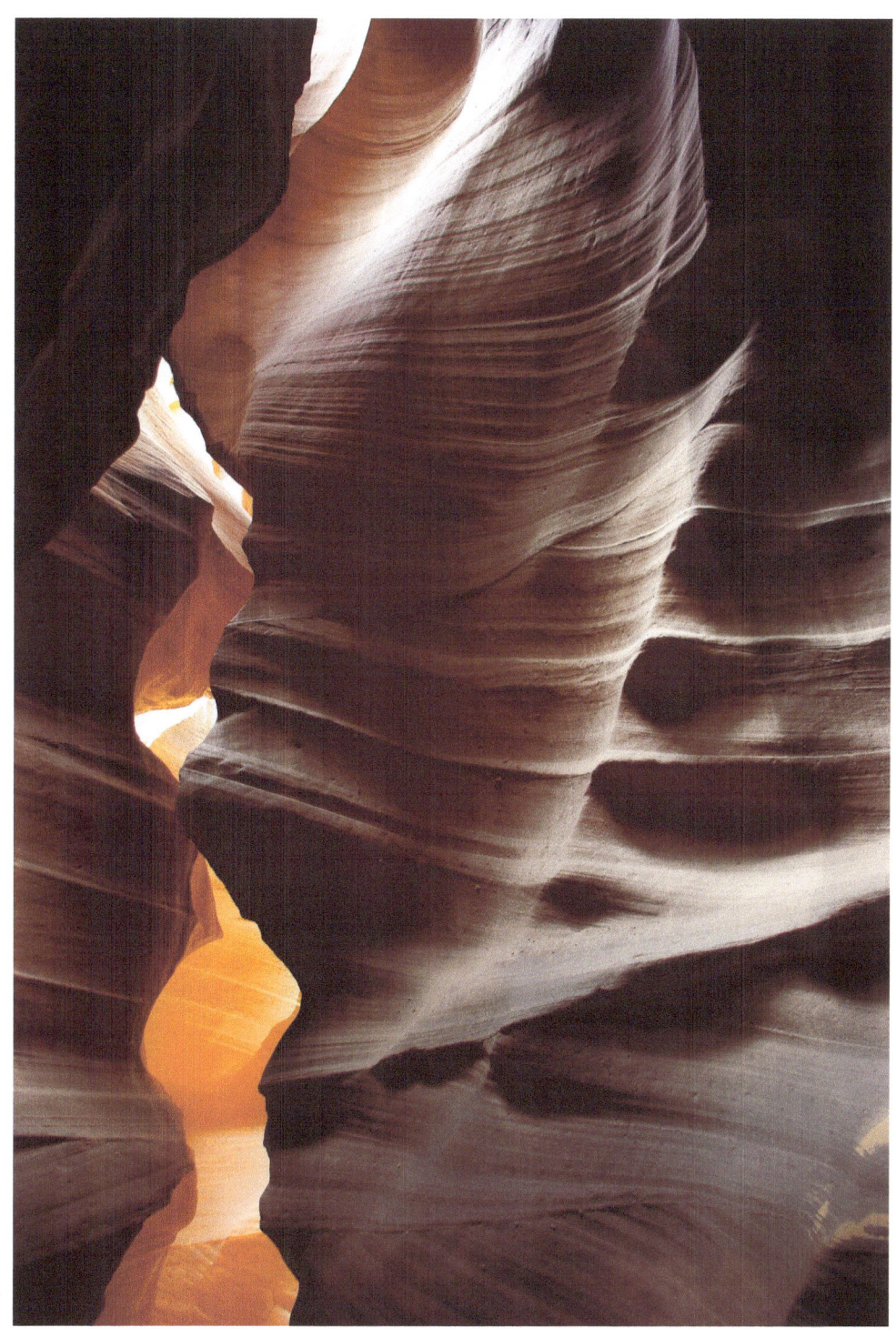

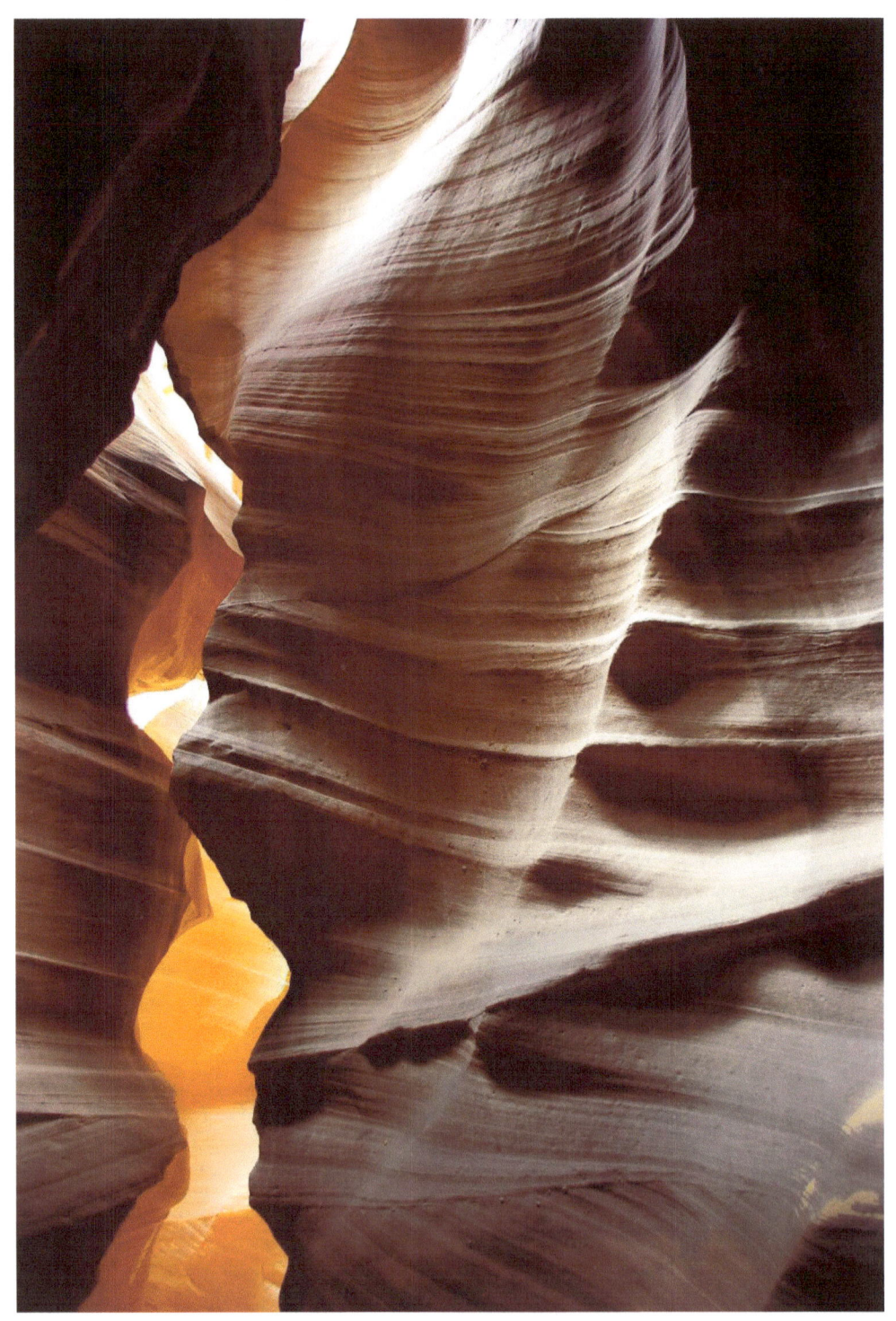

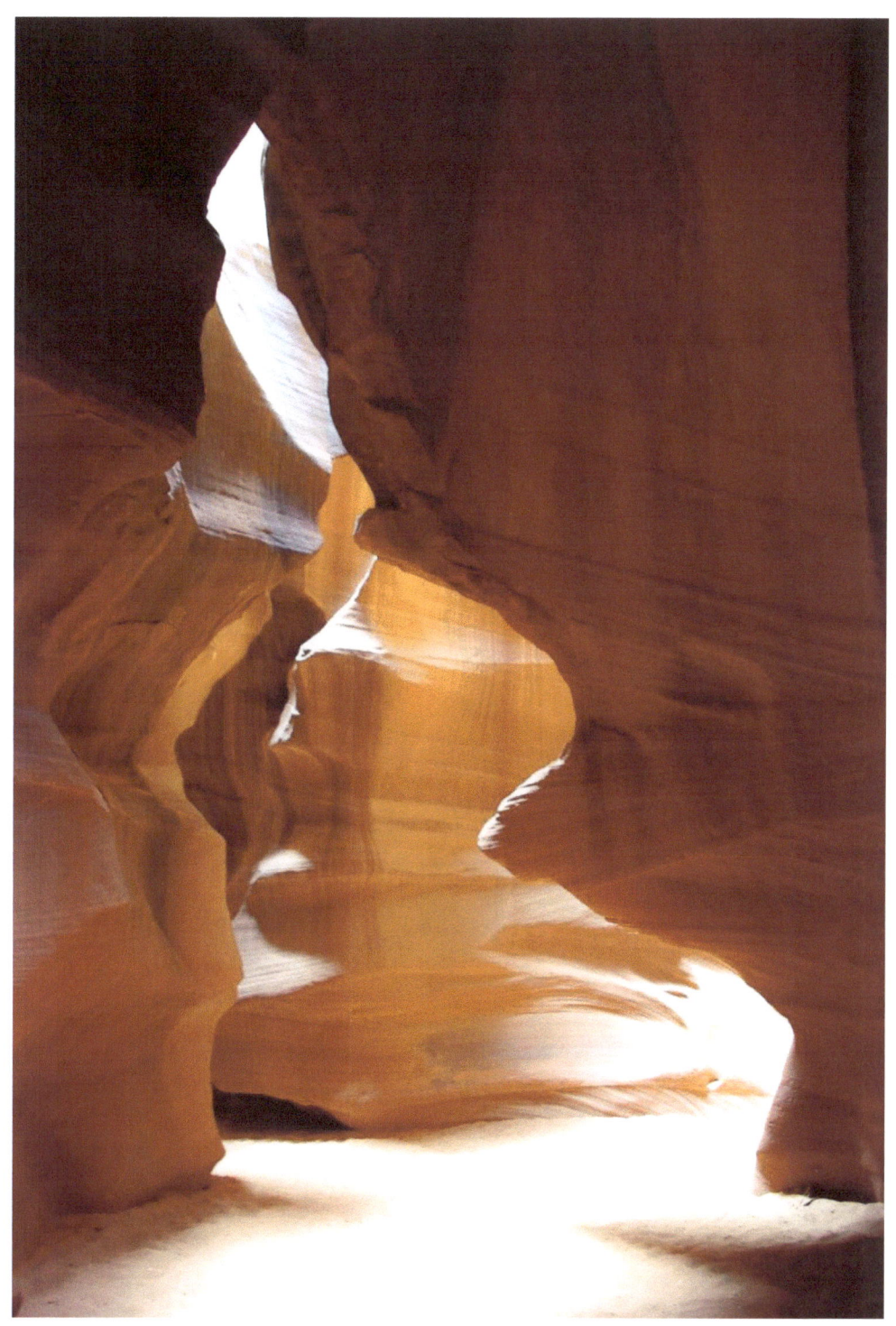

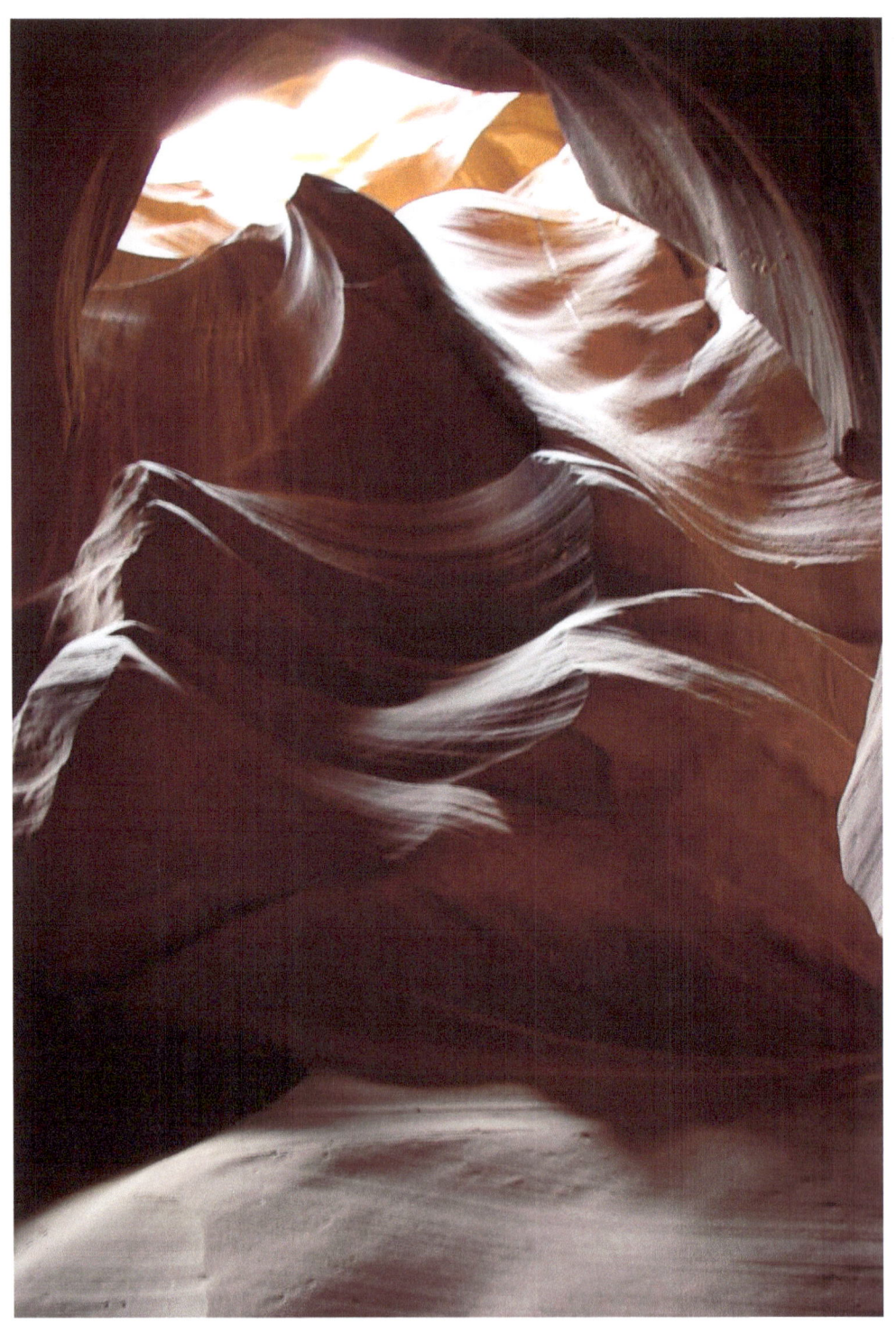

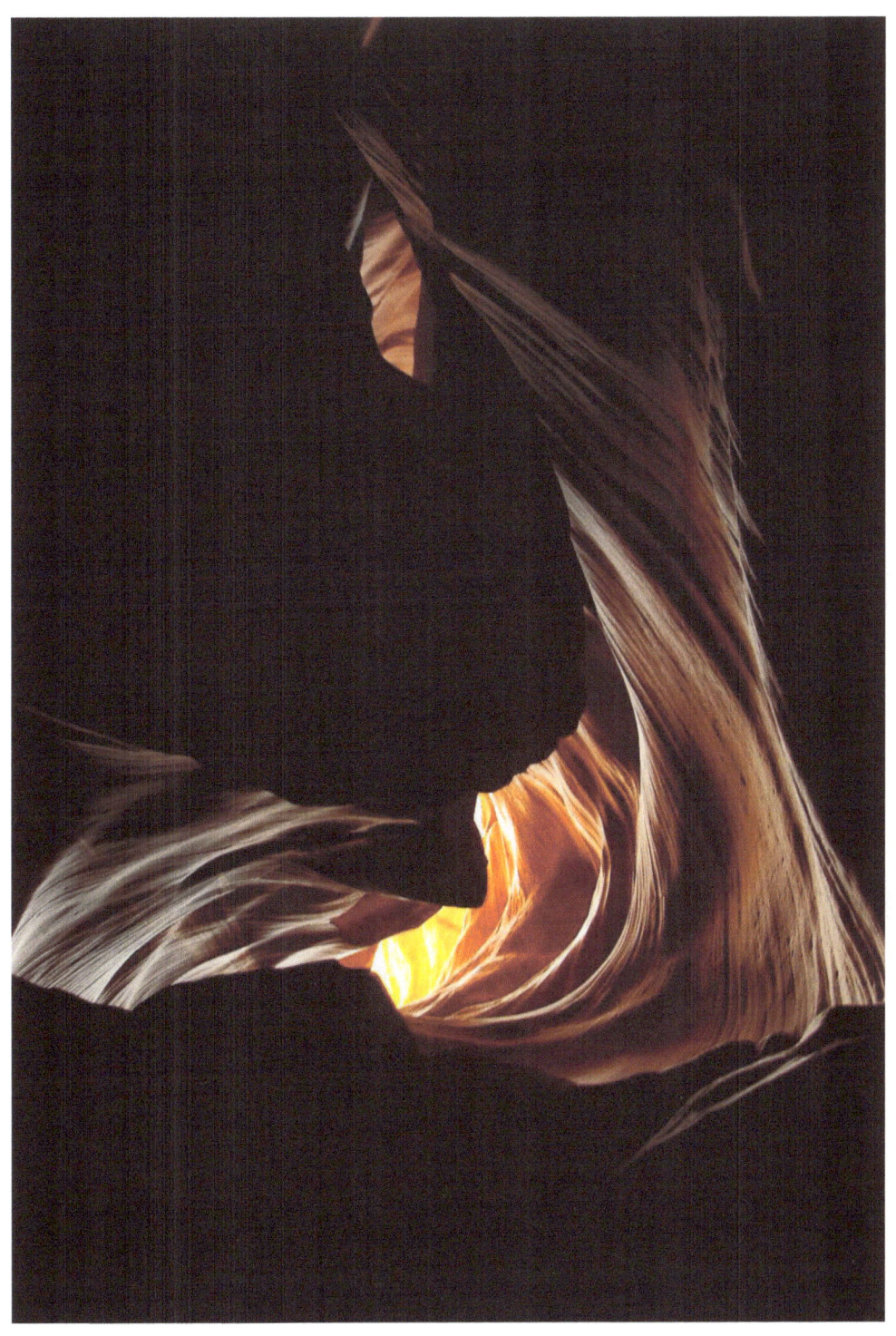

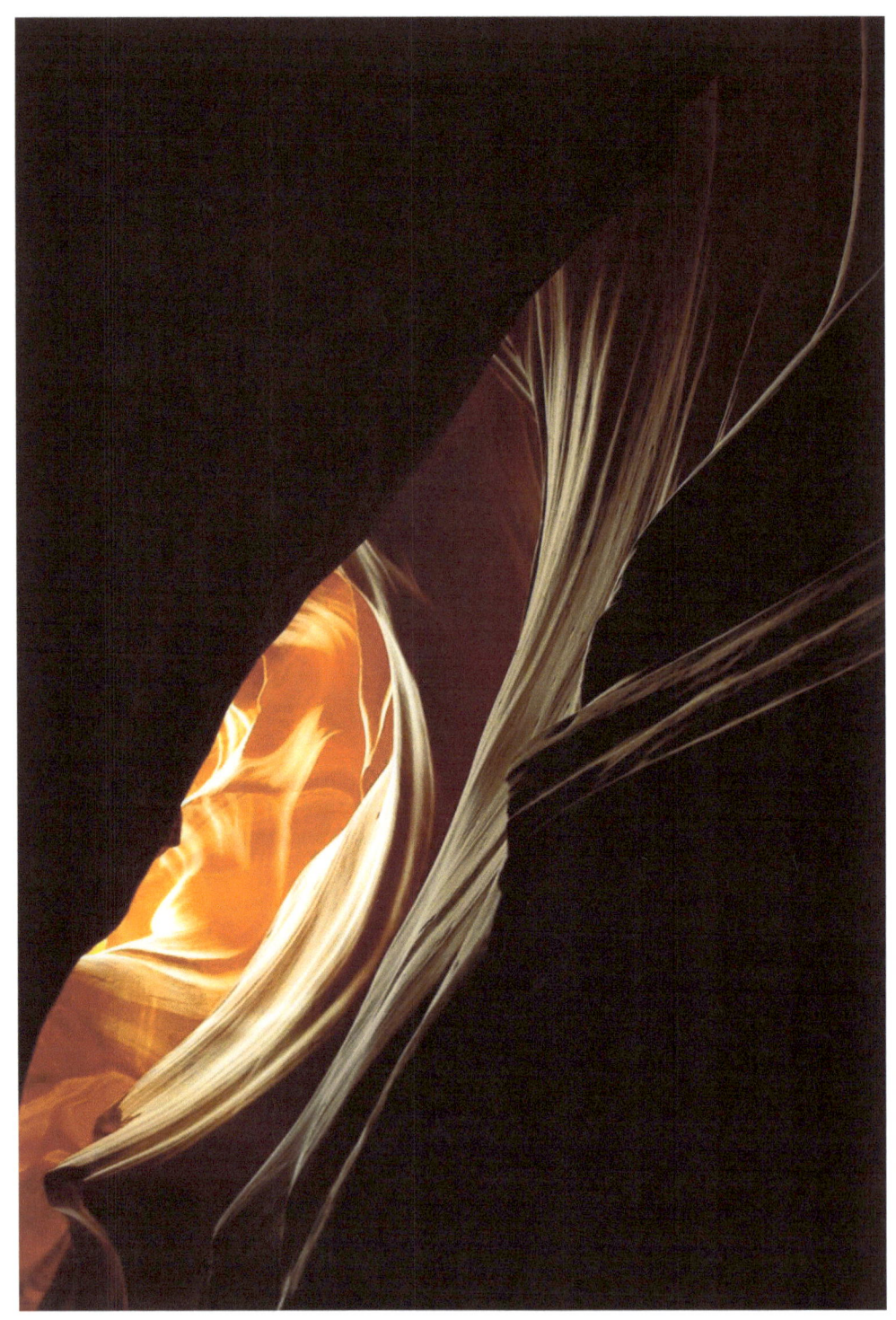

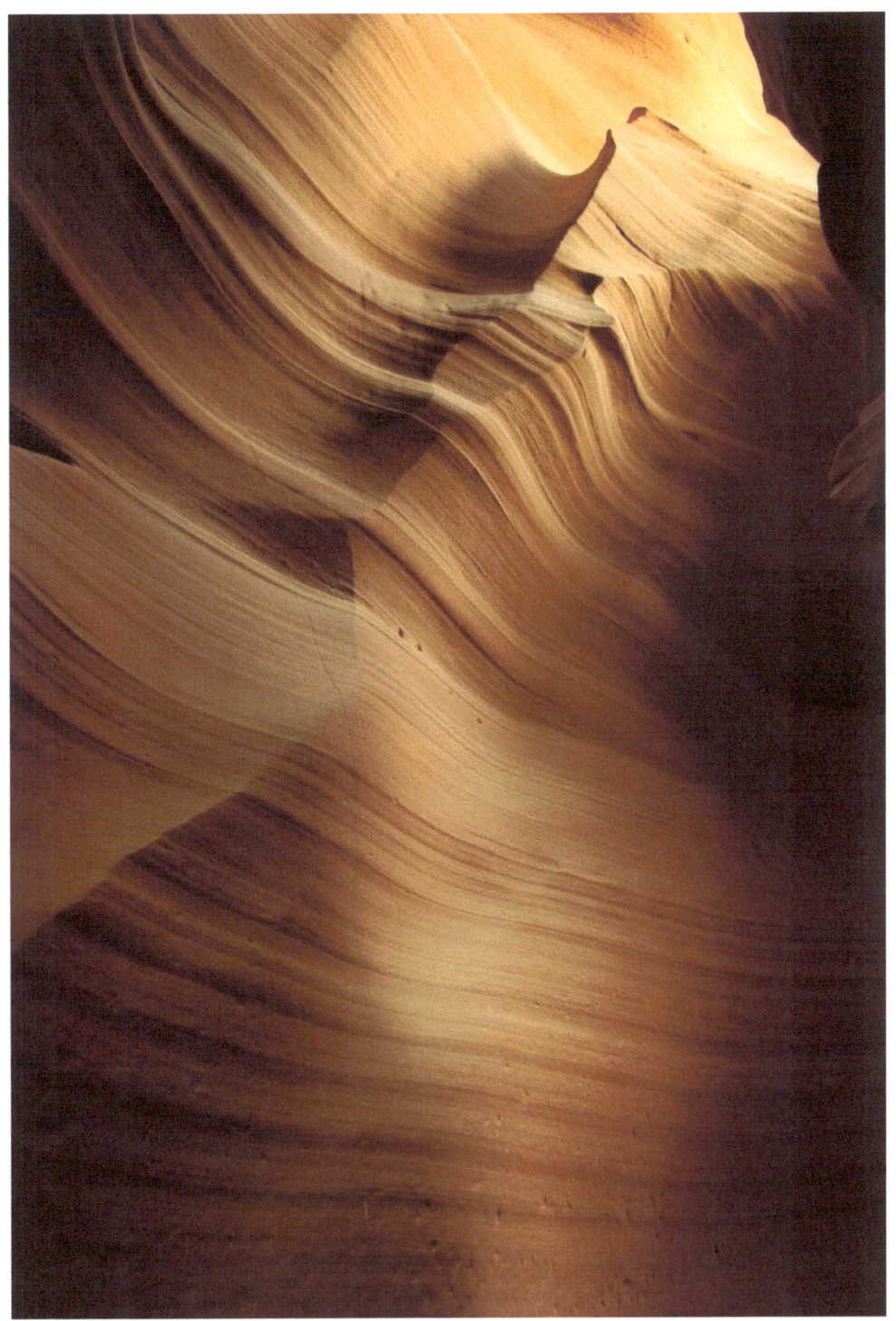

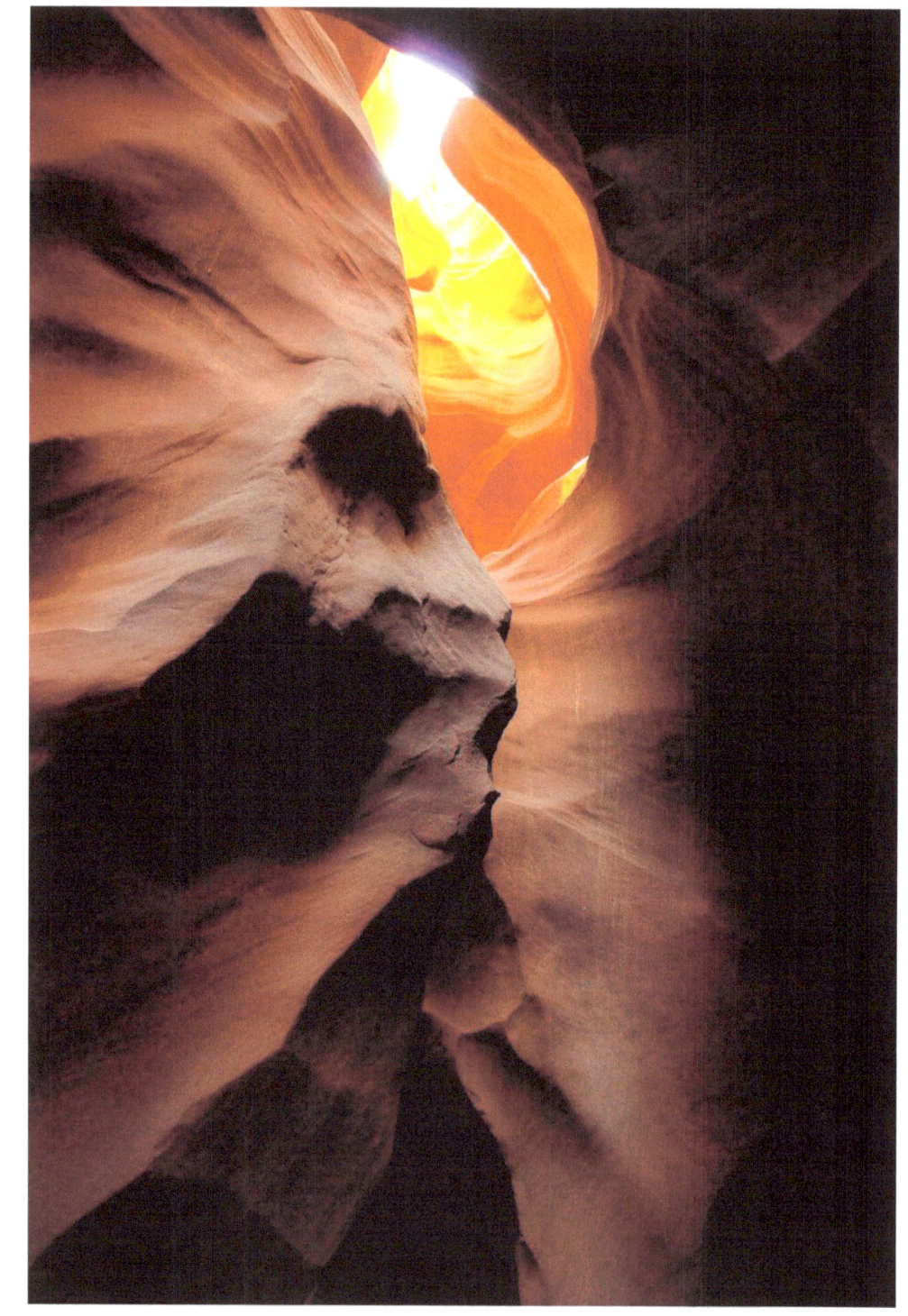

Lower Antelope Canyon

by Jerry Newman

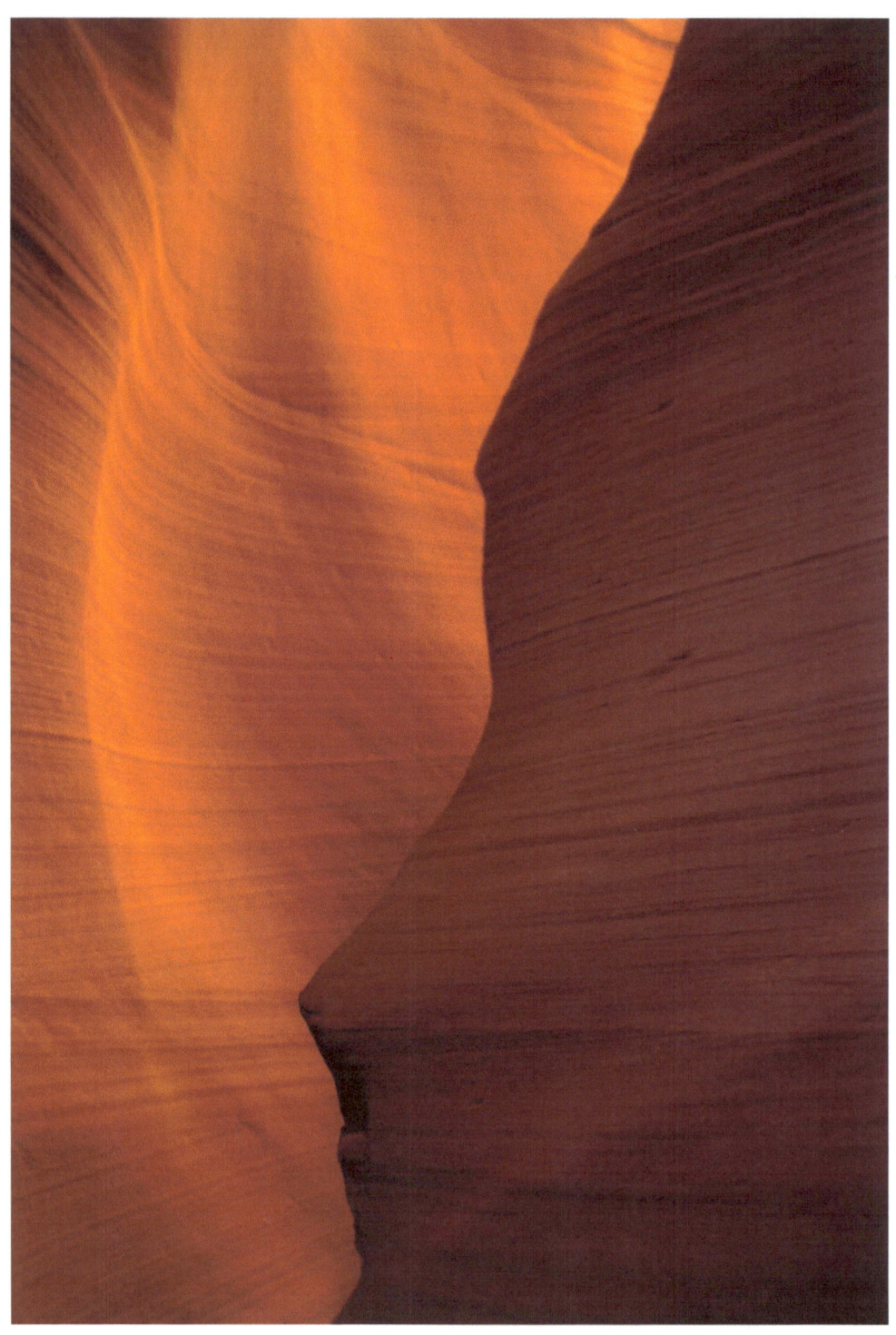

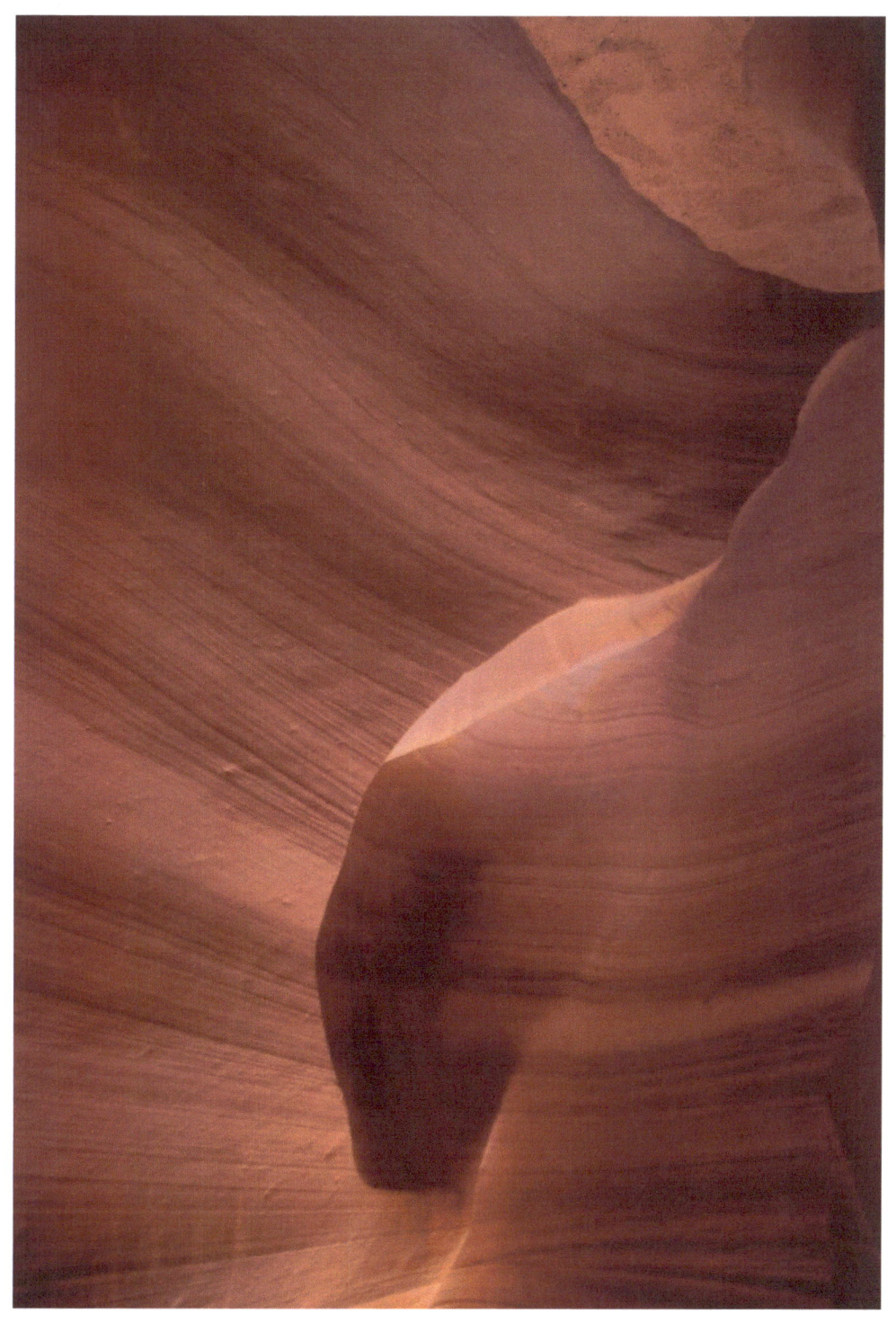

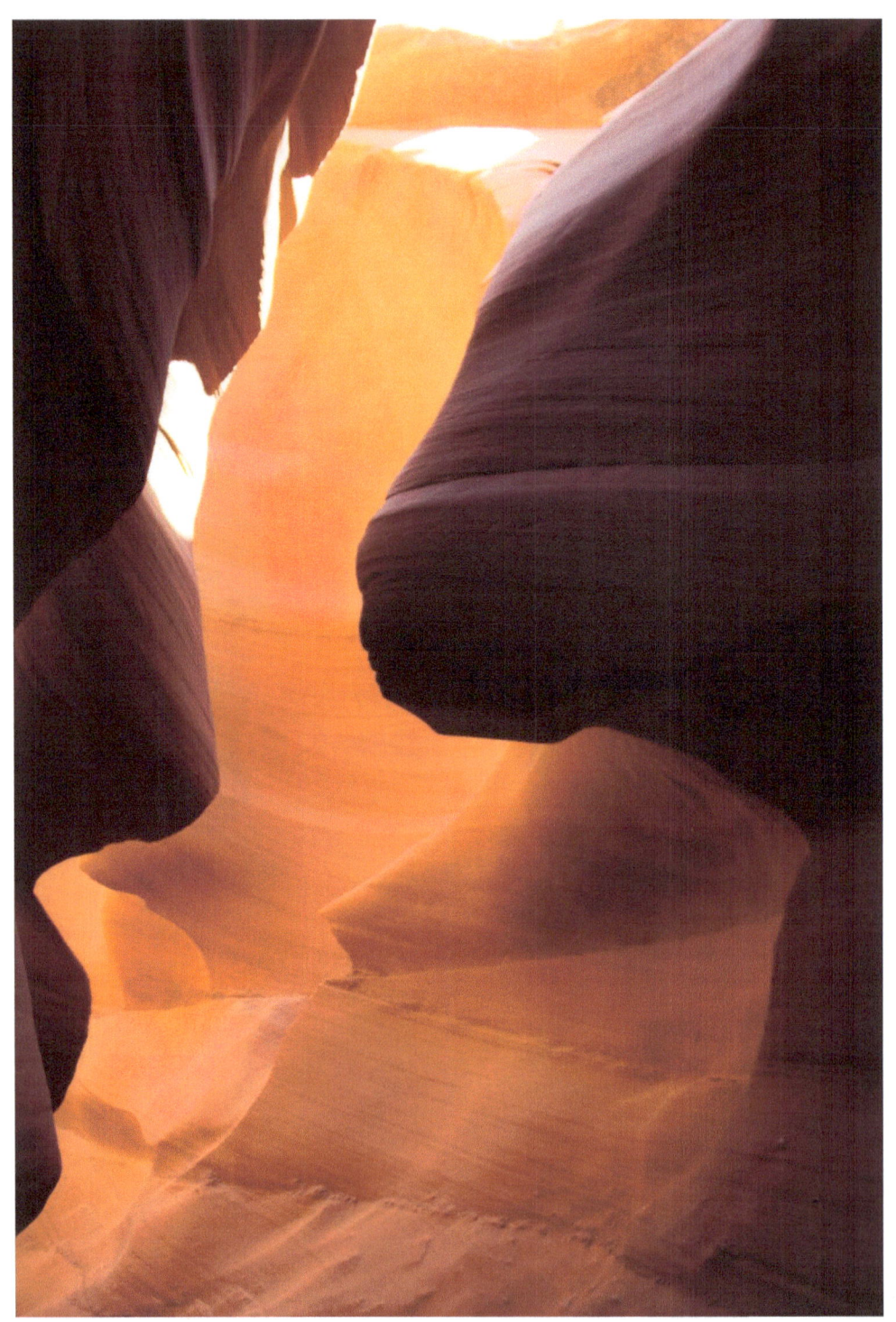

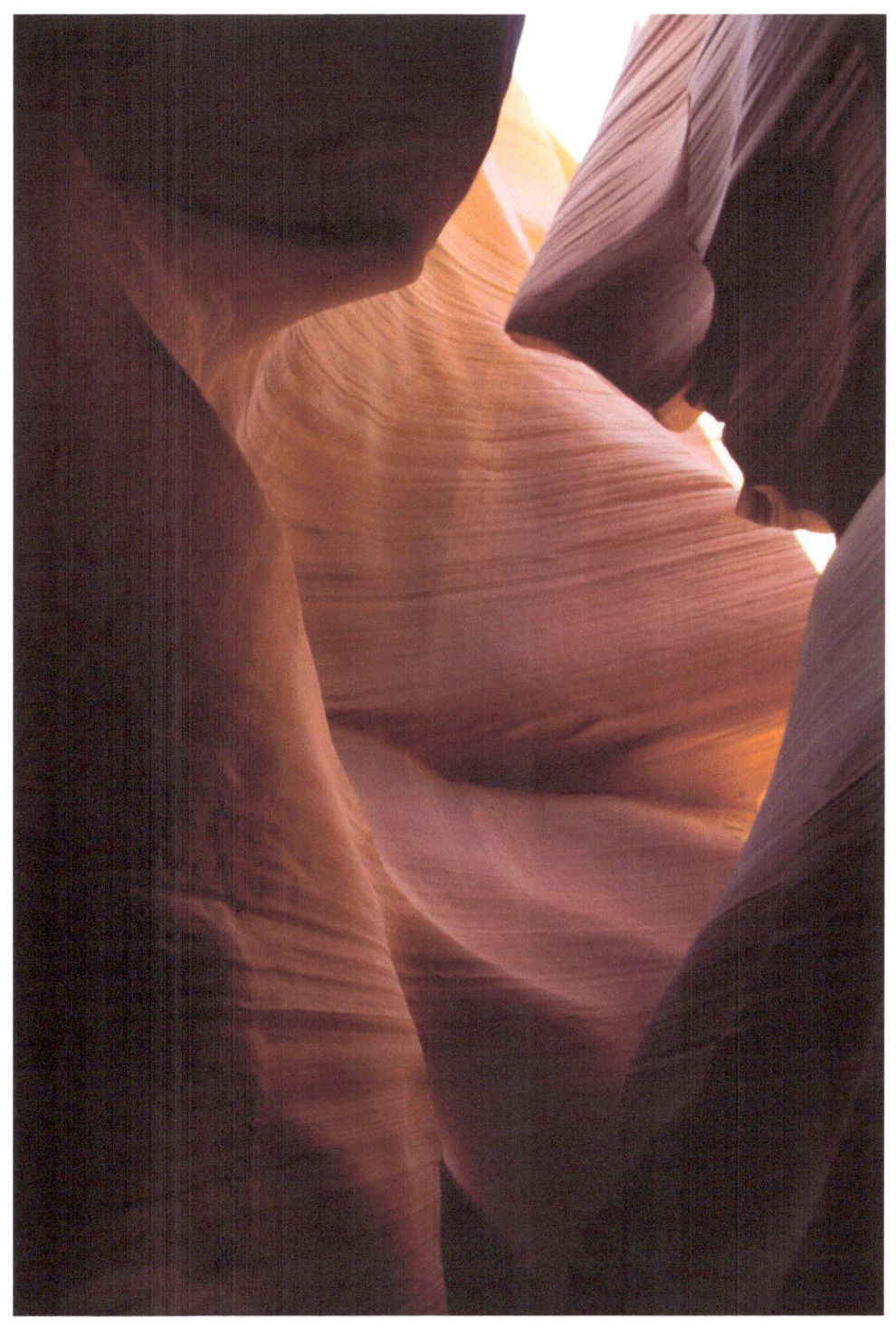

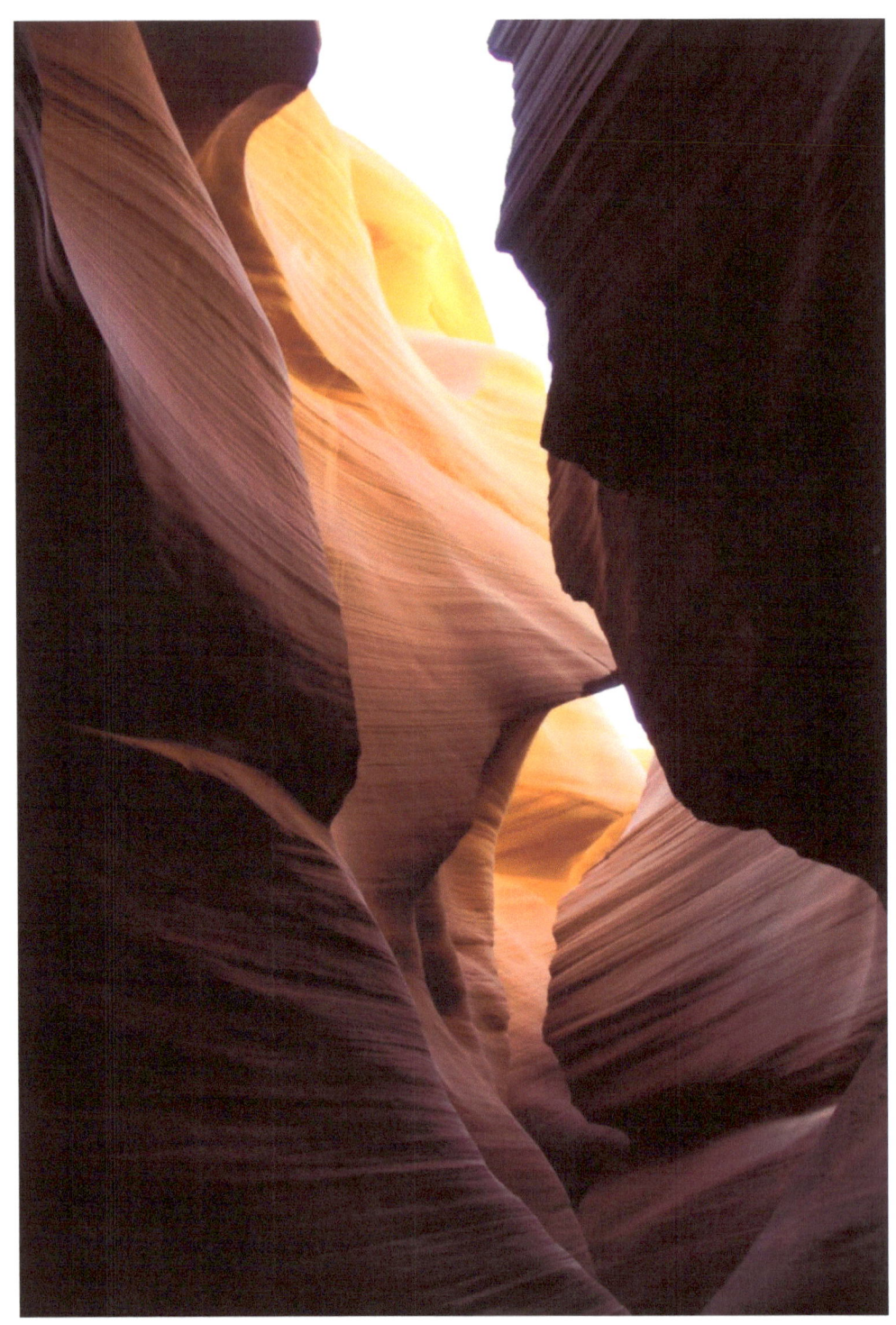

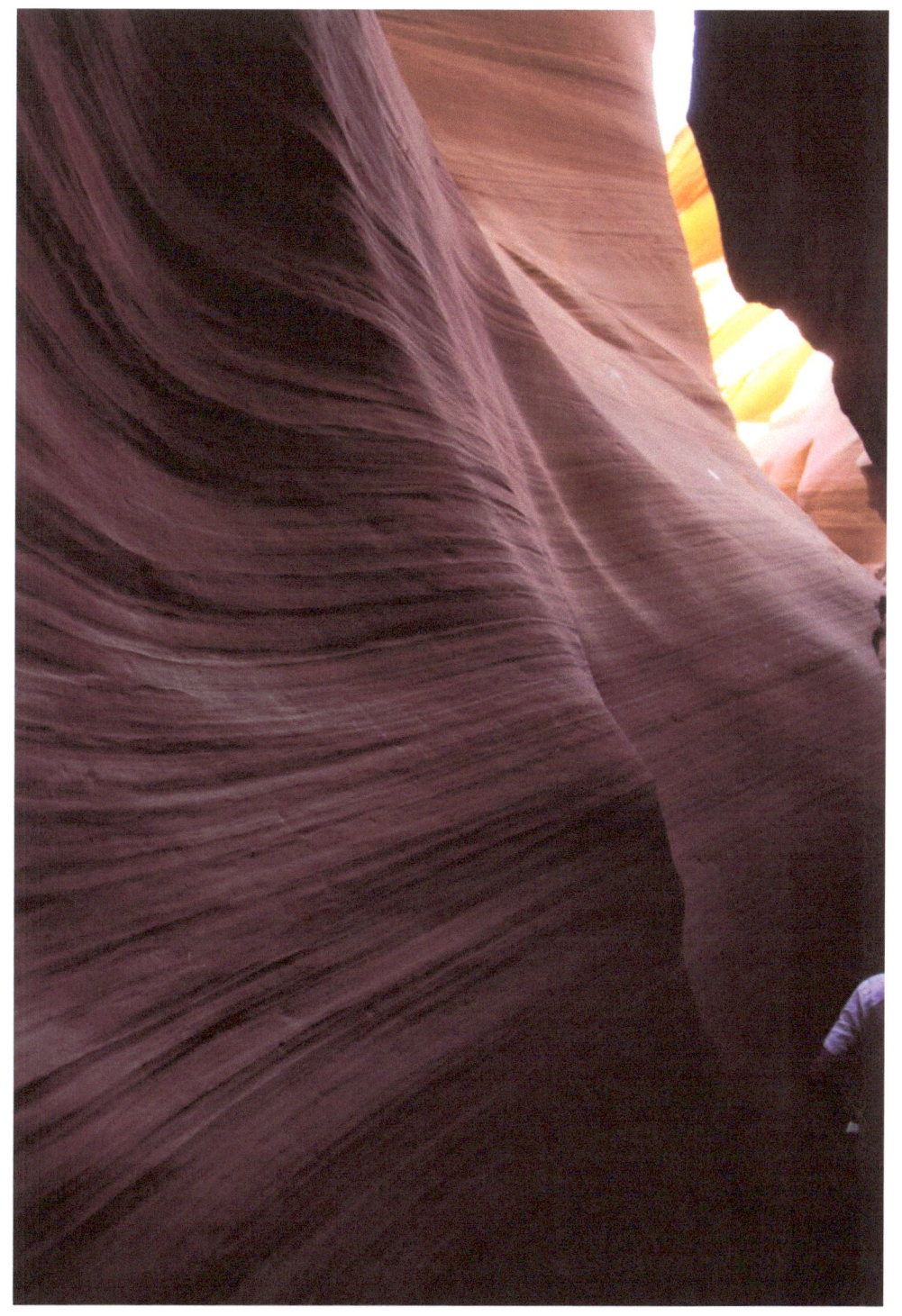

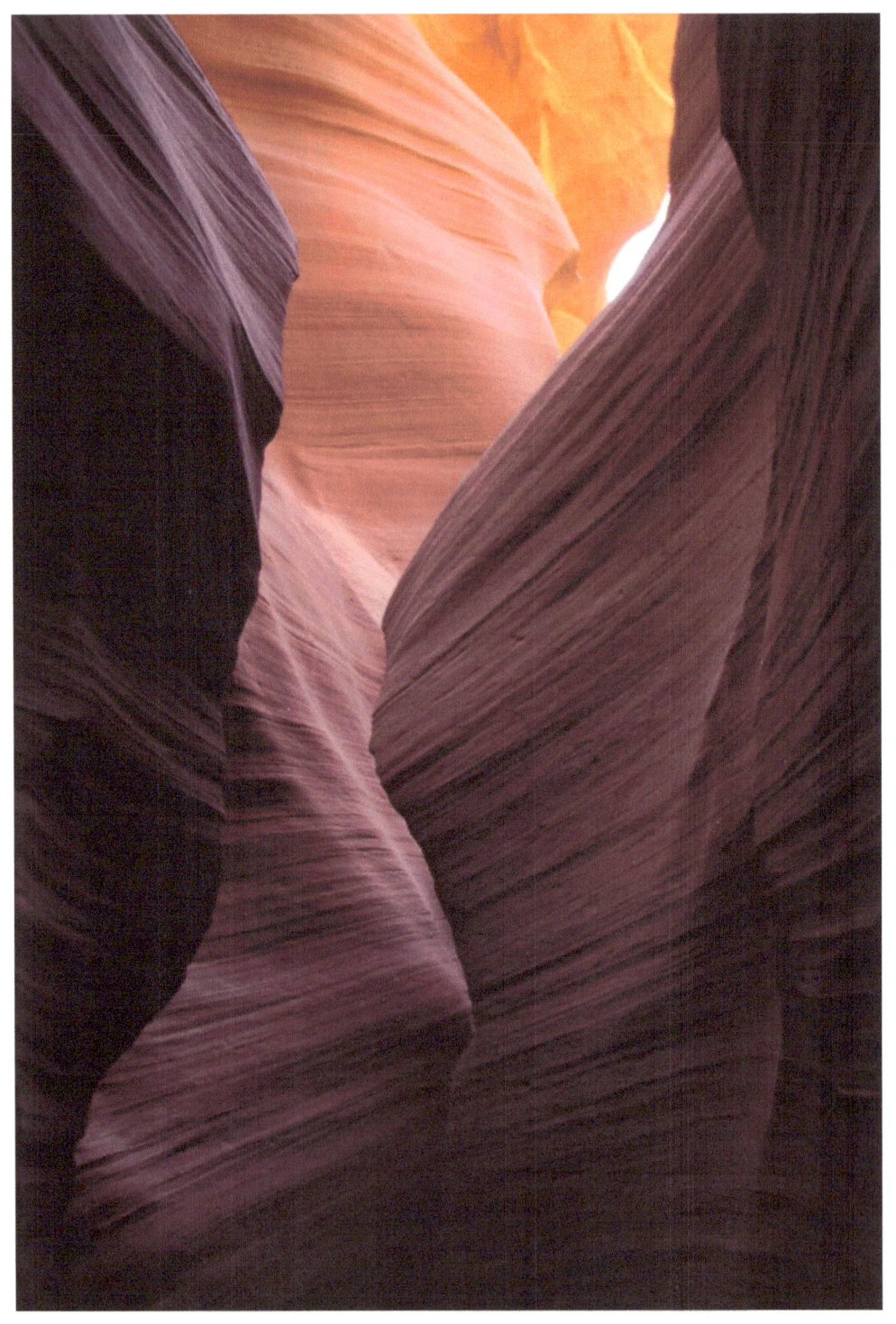

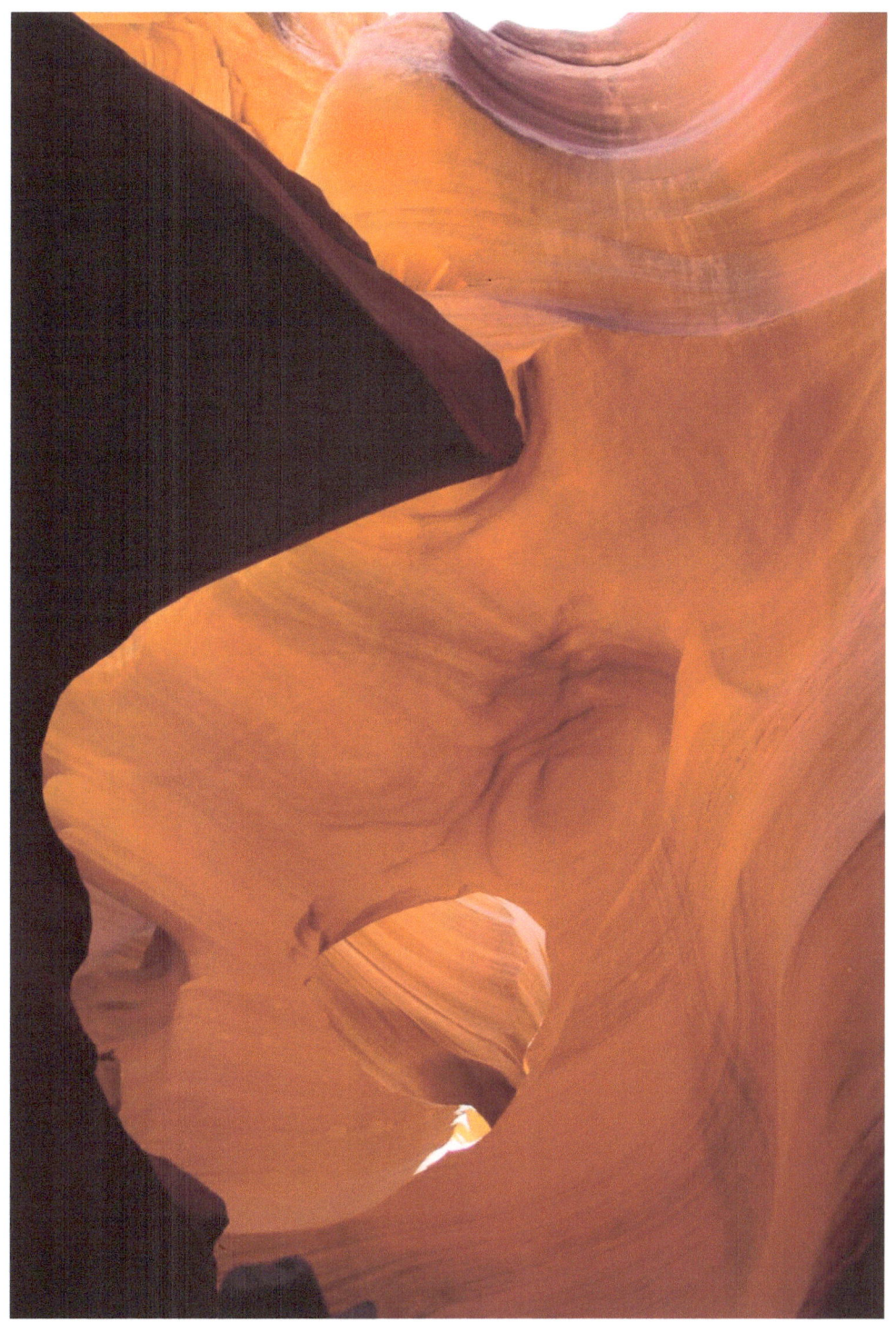

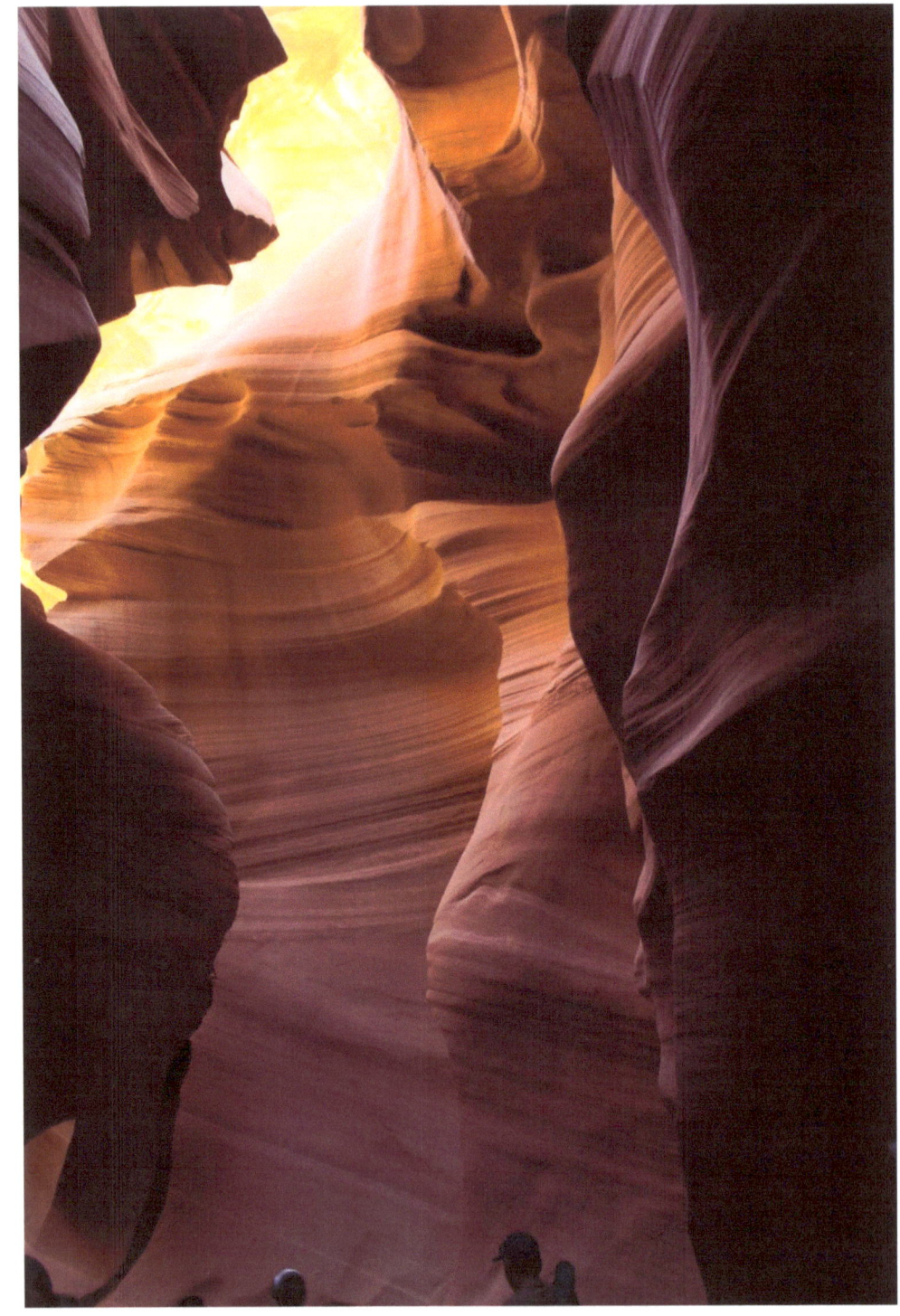

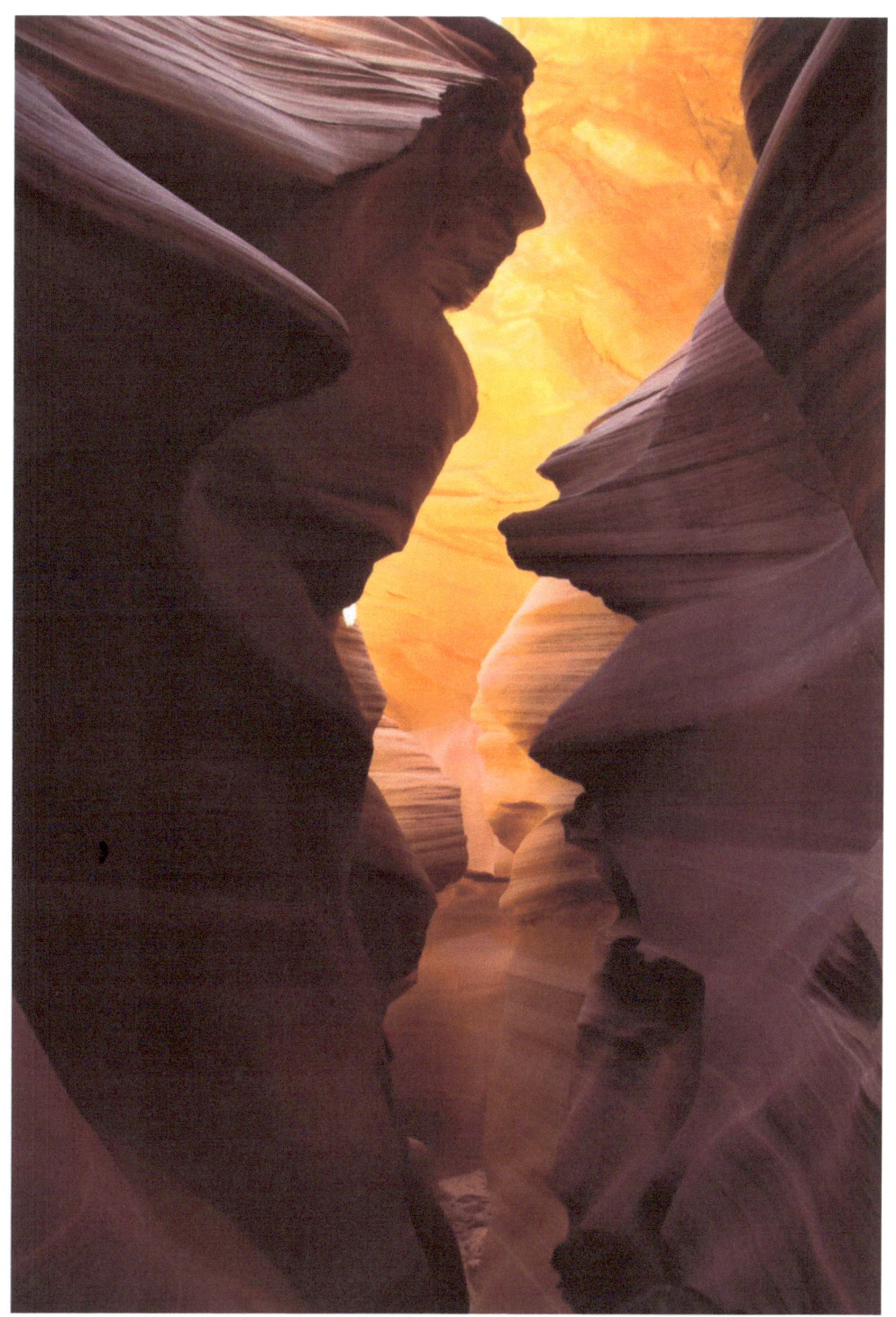

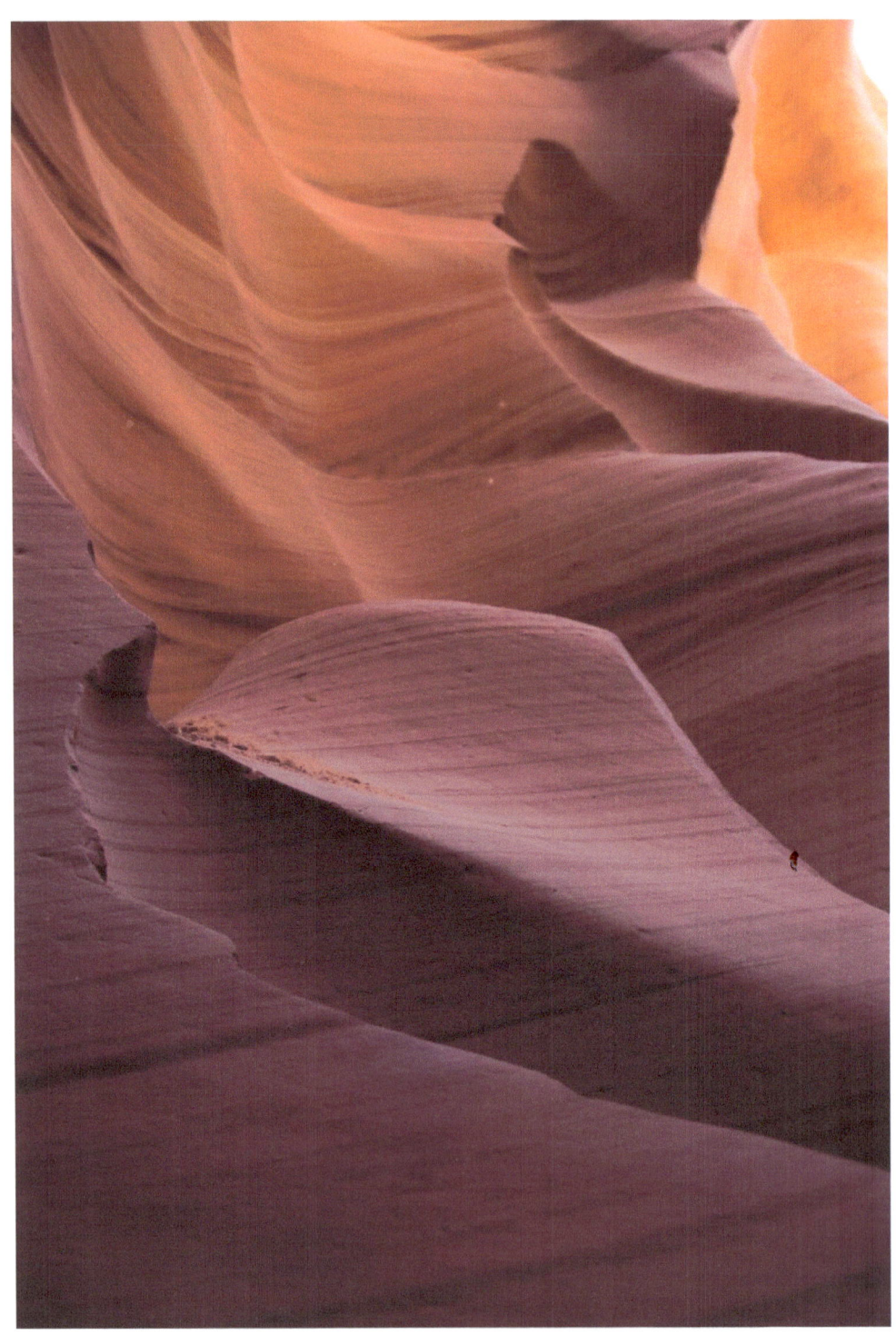

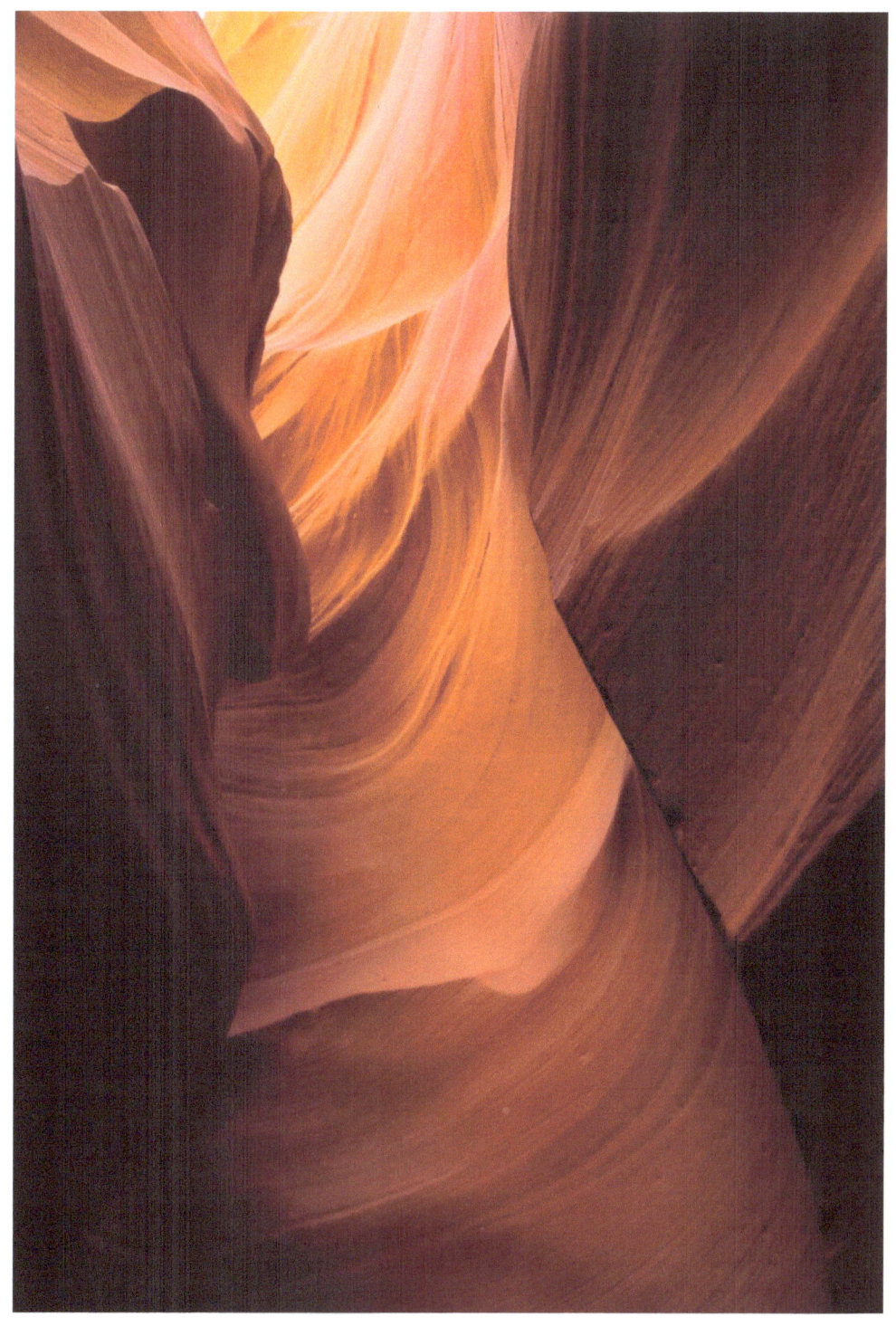

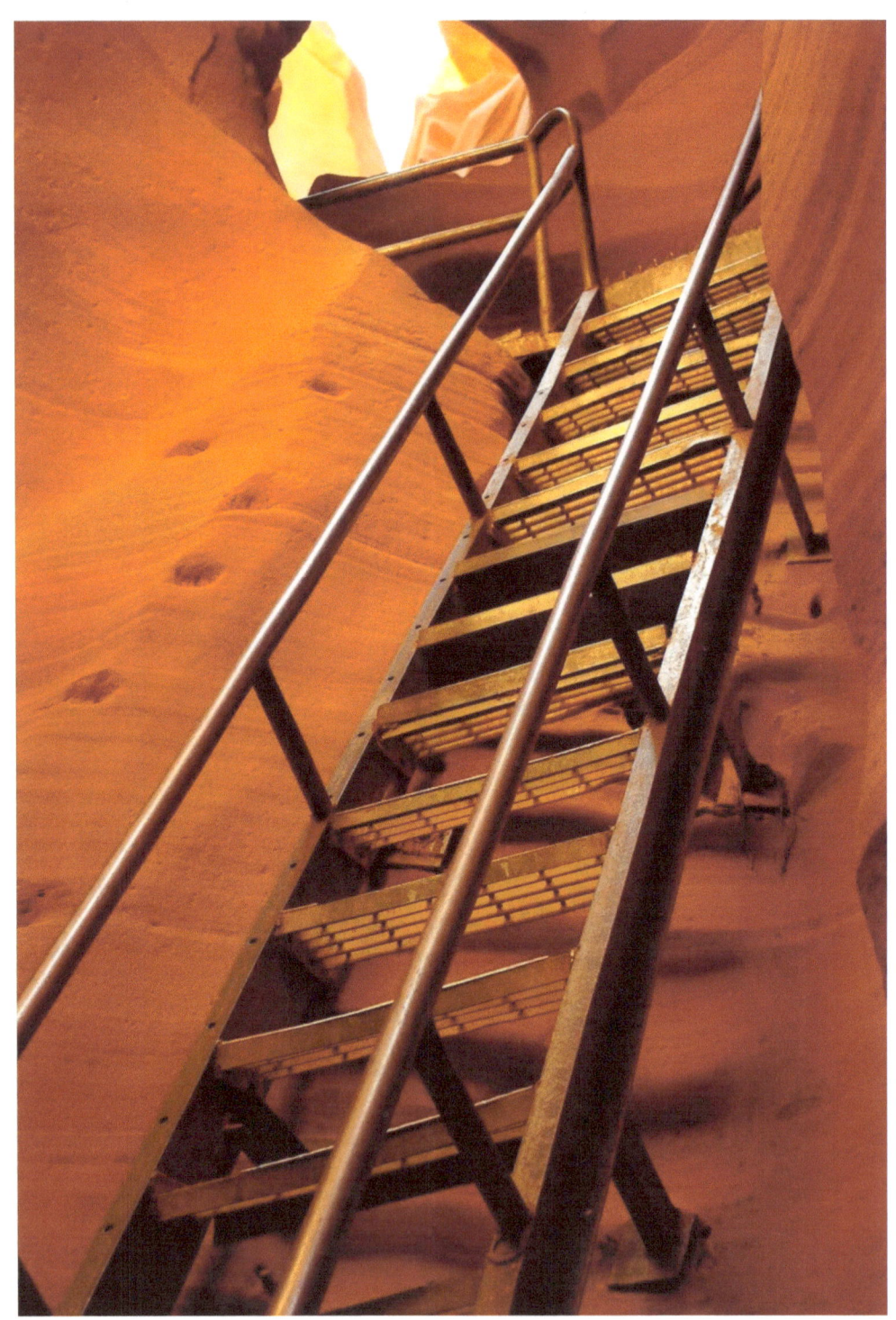

The End

www.ingramcontent.com/pod-product-compliance
Lightning Source LLC
Chambersburg PA
CBHW050807180526
45159CB00004B/1587